IMAGES
of America

ITALIANS IN BALTIMORE

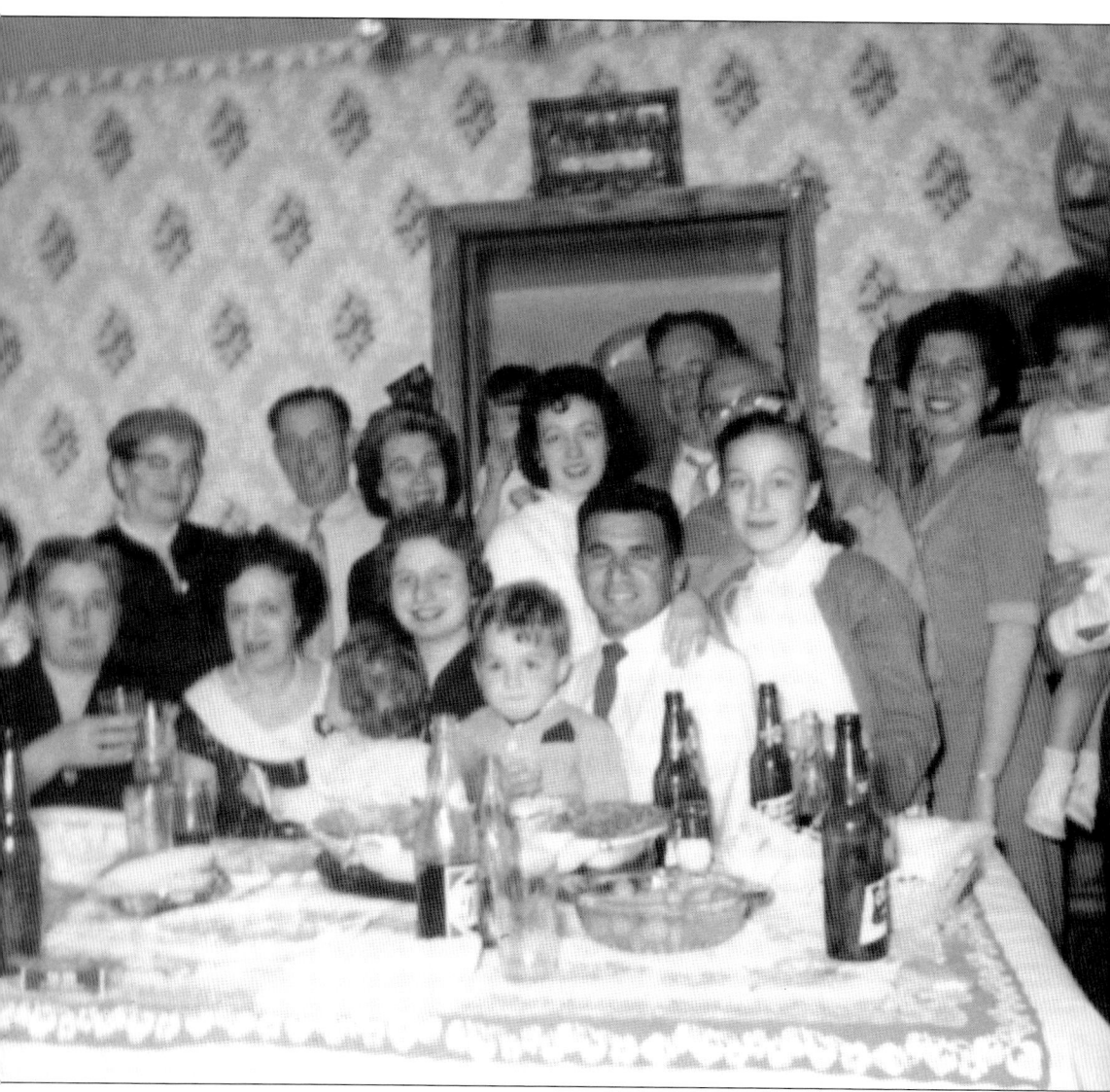

Pictured is a typical family gathering of the Bianchi, Molino, and Mossa families, this one at Sam and Josephine Mossa's house in Dundalk. Italians can never have too many people in a house! "Our hearts are filled with the desire to go back in time, into this picture, that place, that house, and feel the love and togetherness from our great family from Italy who started us all," said Rita Bianchi. "It is my hope others can relate to this scene in a way that takes them back to a similar memory." (Courtesy Bianchi family.)

ON THE COVER: The wedding party and neighborhood friends join bride and groom Marie Bastianelli and James "Jake" Zito at the train station for a send-off on their honeymoon to the Poconos after their wedding on June 21, 1953—a marriage that lasted for 55 years. From left to right are (starting on back cover) Genevieve "Jeannie" Meadows (née Cirelli), Michael Nini and Vince Zito (faces behind Jeannie), Theresa Manna (née Lozzi), Mario Pompa, Ray Cossentino, Marie, Eugene DiSeta, Jake, Phil Marano, Tony Marcantoni, Mike Zito, Jane Sergi, Gloria Trevisonno, Saverio Manna, Shirley Cossentino (née Nevin), Domenic "Fuzzy" Leonardi, and Marian Giardino (née Fideli). (Courtesy Josephine Zito Schmidt.)

IMAGES of America

ITALIANS IN BALTIMORE

Suzanna Rosa Molino

ARCADIA
PUBLISHING

Copyright © 2020 by Suzanna Rosa Molino
ISBN 978-1-4671-0593-4

Published by Arcadia Publishing
Charleston, South Carolina

Printed in the United States of America

Library of Congress Control Number: 2020939526

For all general information, please contact Arcadia Publishing:
Telephone 843-853-2070
Fax 843-853-0044
E-mail sales@arcadiapublishing.com
For customer service and orders:
Toll-Free 1-888-313-2665

Visit us on the Internet at www.arcadiapublishing.com

Ai miei quattro nonni immigrati italiani . . . *to my four Italian immigrant grandparents, who made me Italian. Under your watchfulness, my profound passion for our heritage endures.*

*I am bound to them,
though I cannot look
into their eyes
or hear their voices.
I honor their history.
I cherish their lives.
I will tell their story.
I will remember them.
—Unknown*

Contents

Acknowledgments		6
Introduction		7
1.	Immigrants and Families	9
2.	Growing up Italian	31
3.	Italians at Work	49
4.	Events, Activities, Schools, and Sports	69
5.	Around the Italian Neighborhoods	89
6.	Italian Americans Serving the USA	107

Acknowledgments (Riconoscimenti)

Grazie tantissimo to the photograph owners who submitted to this splendid collection—without you, there is no book! Please accept my gratitude for trusting me with your family's treasured photographs and your willingness to learn scanning—no matter how often I asked for a do-over.

To *mio amico*, Andrew Lioi, 94, my "go-to-guy" who vividly described life in the Italian community "back then"—what an impressive memory! And to *mia amica*, Denise Giacomelli Loehr, for your assistance and enthusiasm. You win for having the largest quantity of photograph topics.

To my precious *cugini* (cousins) Gary Molino and Johnny Manna for answering oodles of questions about growing up Italian in Little Italy.

To Deb Carson (also known as Val) for your splendid research support and listening to my yammering about this book day in and day out . . . *dayenu*.

To Caroline Anderson, my title manager at Arcadia, always at the ready to efficiently respond to my barrage of questions and guide me through the production phases—you have earned the title of "Person I Have Emailed the Most."

To my puppy Lupini Martino, who good-naturedly waited for *Mamma* to finish writing each day so I could throw your favorite squeak toy 57 times. Good boy. *Bravo*.

Nota dell'autore (author's note): The photographs and captions included in this book offer a brief but fantastic glimpse into the history and lives of some Italian immigrants in Baltimore. It came to life owing to the hundreds of images and the personal information generously supplied to me by their families. While each photograph I received was considered, they could not all be included. In no way do the selected images and stories represent a comprehensive history of Baltimore's Italian community, nor does this book intend to represent all of its families, businesses, neighborhoods, parishes, and organizations.

INTRODUCTION

Two miles down the beach near my Florida winter residence, a long, dilapidated fishing pier jutted out into the Gulf of Mexico. As this book increased, page by page, the pier decreased piece by piece during its demolition. Each time I ventured onto the beach for a walk, bike ride, or to watch a sunset, more rusty segments had disappeared. Eventually, nothing remained but air. Water lapped at the shore where wood pilings once stood, deeply embedded into rock to weather rough surf and hurricanes, much like my Italian ancestors embedded themselves into life in the United States.

Now, as I pass the site where the familiar pier once stood, I get the sensation it is still there. I cannot see it any longer, but I feel it . . . as I feel my four *nonni, zie, e zii* (grandparents, aunts, and uncles)—Italian immigrants long gone, yet forever cherished. They are set in history like the sun disappears below the horizon. Whether I am in Florida, in my Baltimore County home, or across the Atlantic visiting my beloved *famiglia* on the picturesque island of Sardegna, Italia, I am surrounded by my grandparents' tender presence. I live with a continual sweet nostalgia of growing up Italian.

Like that fishing pier, Baltimore's Italian immigrants weathered countless storms, revealing incredible fortitude and bravery as they sought better lives for themselves and subsequent generations. Perhaps those of us in today's Italian community have only scant knowledge of our ancestors' sagas and these tattered vintage photographs, yet our blood flows with their passion for enjoying life, working hard, praying fervently, and loving our families. We are what they chose to be: Italian Americans.

Through this book and other Italian-related books I have written, coupled with my mission of promoting Baltimore's Italian community through my nonprofit organization Promotion Center for Little Italy (PromotionCenterforLittleItaly.org), I continually honor my Italian heritage—and yours.

One
IMMIGRANTS AND FAMILIES

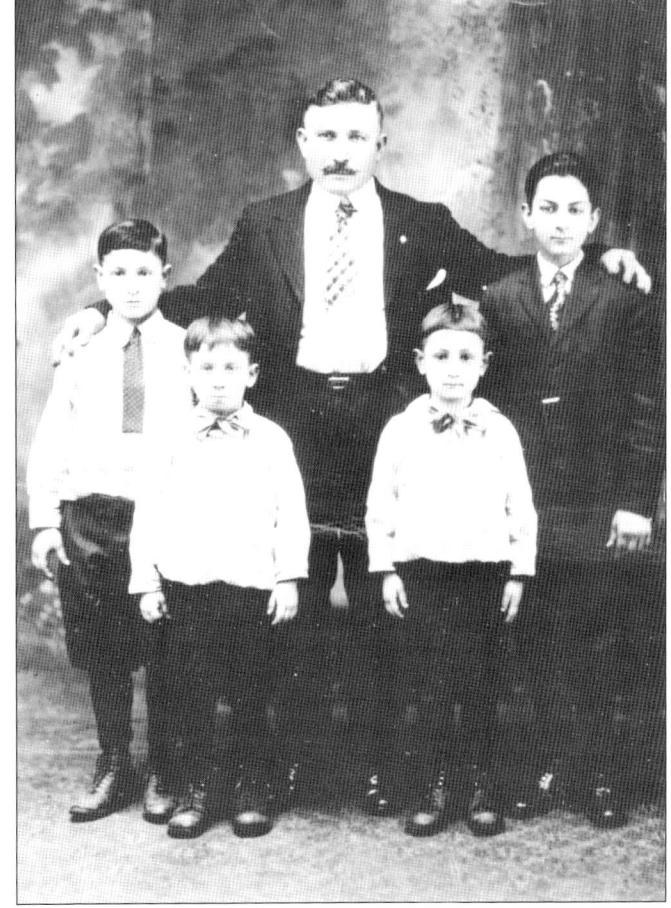

Carmelo Meo (1870–1935), from Riposto, Sicily, Italy, poses around 1920 with his sons Fillipo, Carlo, Giuseppe, and Salvatore, two of whom were born in the United States. Carmelo and his wife also had three daughters, born in Sicily: Petrina, Rosa, and Teresa. Carmelo is the grandfather of Anna Giro Giacomelli of Little Italy and great-grandfather of her daughters Evelyn, Denise, and Reneé, also raised in Little Italy. (Courtesy Denise Giacomelli.)

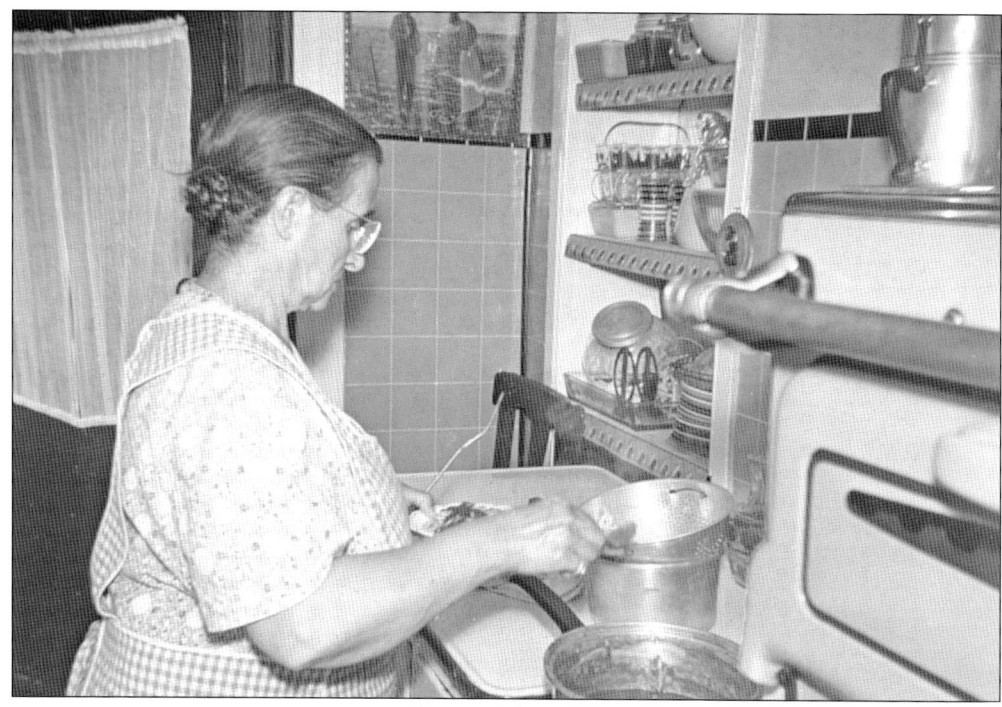

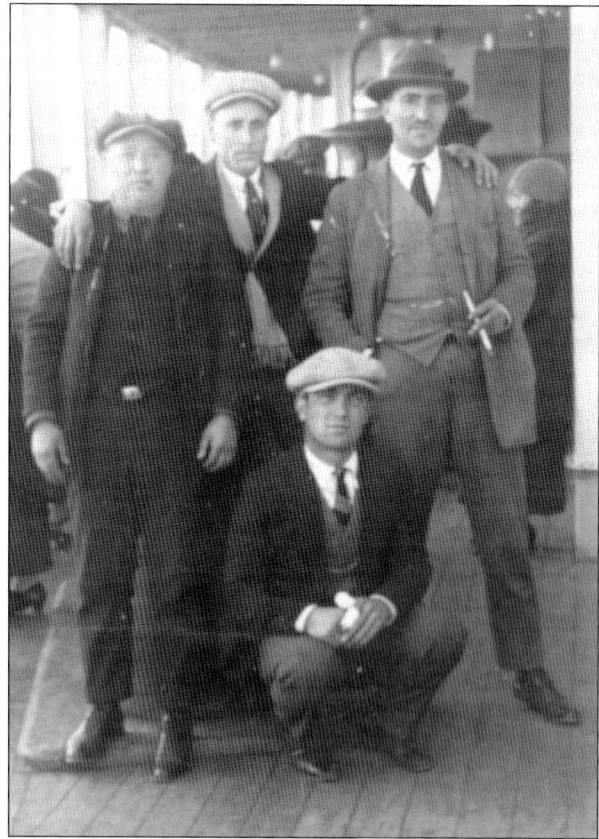

At age 22, Salvatora Mogavero (pictured here around 1942) and her 14-year-old sister, Nicolinee, arrived in the United States from Isnello, Sicily, in 1904. Salvatora married Gregorio Mugavero, who immigrated in 1893 from Caltavuturo, Sicily. The Mugaveros operated a bakery in their home at 913 Fawn Street and were the parents of Little Italy icon Marion "Mugs" Mugavero, who owned a popular corner hangout, Fawn Confectionery, from 1947 to 2014. (Courtesy Thomas C. Scilipoti.)

Pasquale Manna (kneeling) was on his second voyage to America from Vasto, Abruzzo, in 1924 on the steamship *Duilio*. His first passage was at age 12 in 1917 with his mother, Mary Manna (née Tana), arriving in Boston from Naples. Crossings from Italy took several weeks to reach the East Coast of the United States and sailed from various ports. (Courtesy Johnny Manna.)

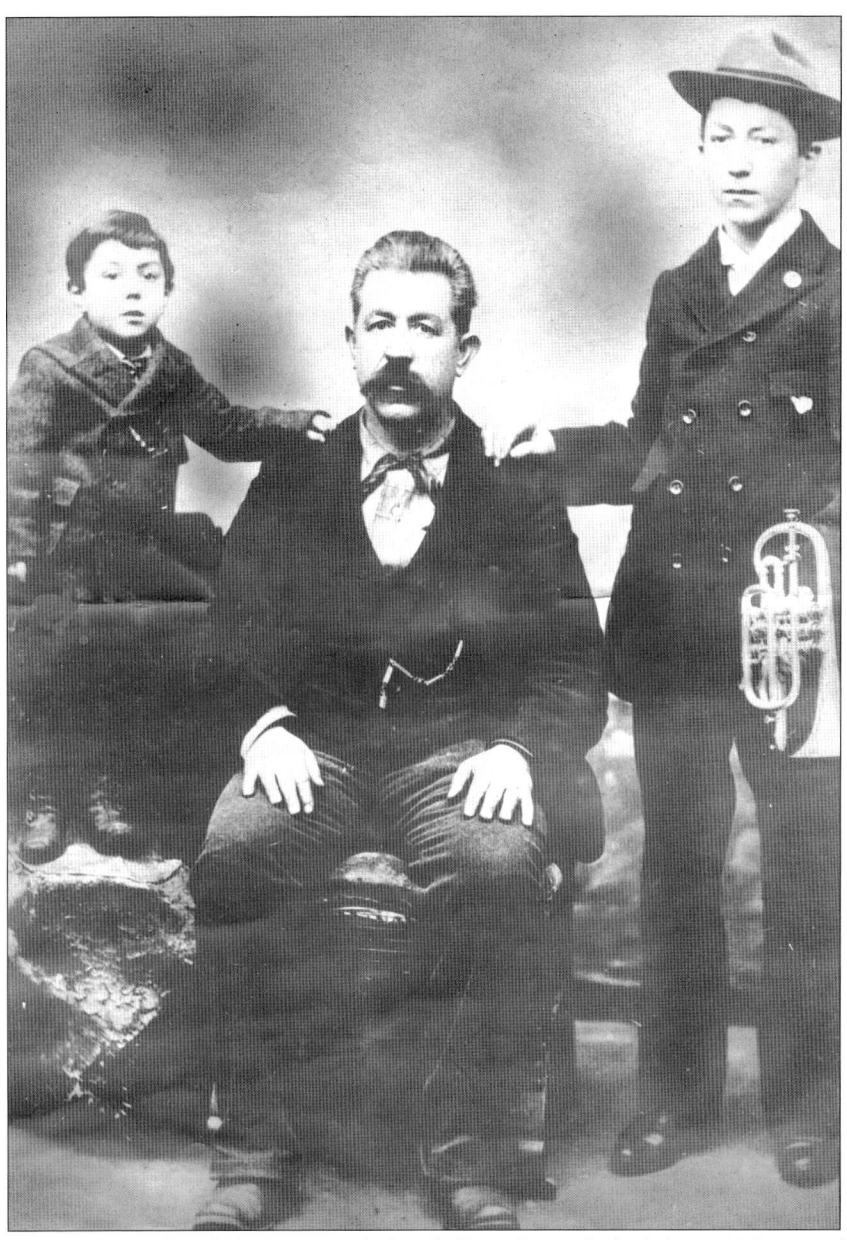

Angelo Pente, pictured with his sons Nicholas (left) and Joseph (right) in 1895, arrived in the United States around 1893 from Abruzzo, Italy, into Little Italy before it had its name; he lived amidst mostly German, English, Irish, and Jewish residents. Working various jobs as a locksmith, shoe repair shop owner, and street musician, Angelo saved to purchase a house at 222 South High Street in 1904; it stayed in the Pente family for 113 years. "The original house had gas burners, no electricity, and two outhouses," said the late John Pente (1910–2010), Angelo's grandson. Boarders occupied the third floor, and John's grandmother cooked and washed clothes for them. John lived there during his lifetime—Little Italy was his entire universe. He was known to many as "Mr. John," the kind Italian who allowed the use of a third-floor bedroom to project movies onto a wall across the street during Little Italy's long-running Film Fest (1999–2017). The house is marked with a plaque and deemed a Baltimore Centennial Home. (Courtesy Joe Pente.)

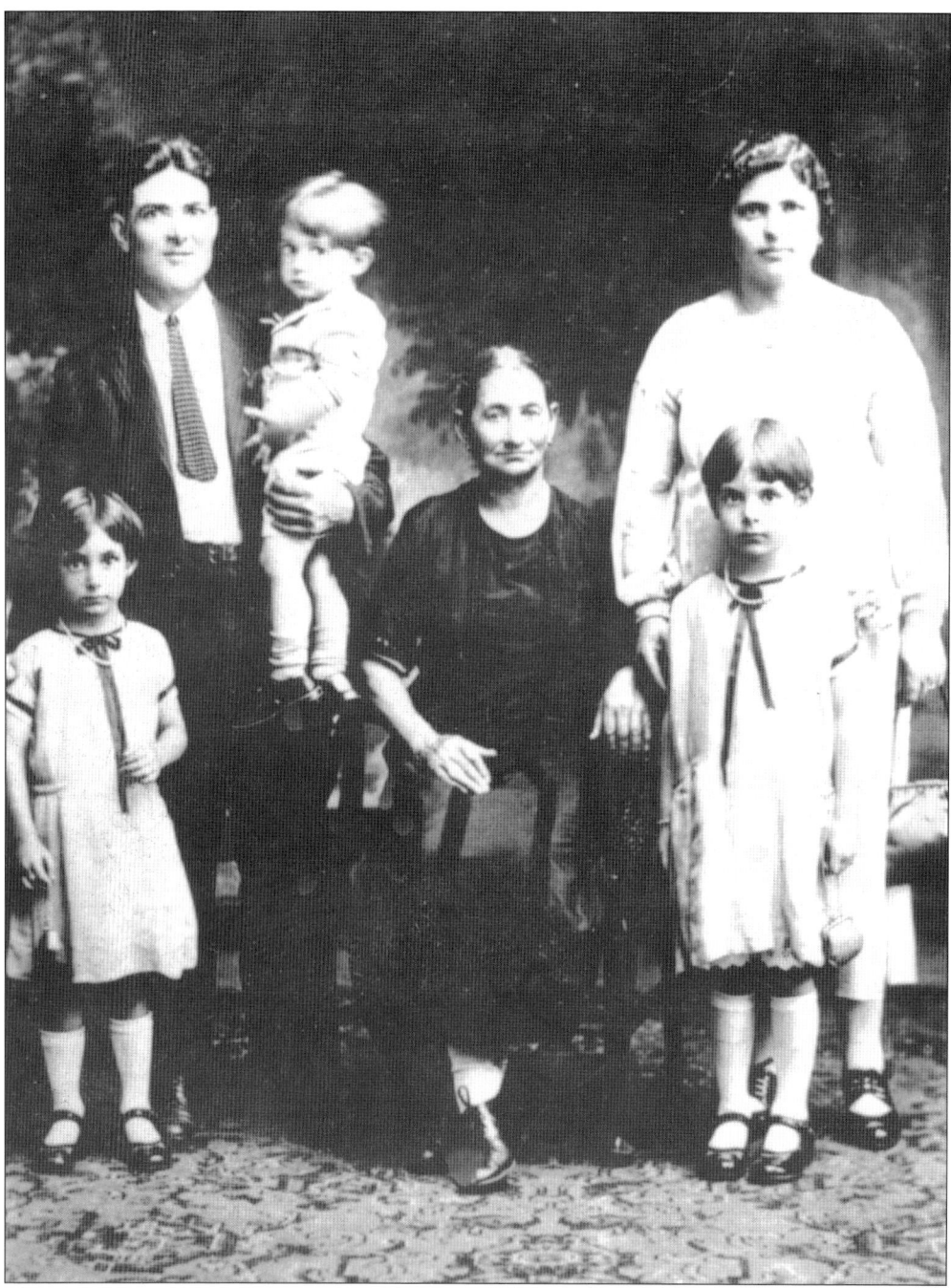

Around 1927, the Aversas are pictured with their children and mother/mother-in-law. From left to right are Victoria, Nicholas, Samuel, Theresa Corasaniti (née Ranieri), Catherine Aversa (née Corasaniti), and Theresa. Thousands of immigrants arrived via Ellis Island. The adults are immigrants from Davoli, Italy; the children were born in the United States. As residents of Port Street, they lived among poor immigrants in tiny houses. Nicholas was a bricklayer, Catherine worked in the garment district, and Theresa was a midwife. "My dad told me my grandfather Nicholas was little but strong as an ox," said Cathy Aversa Coleman. (Courtesy Cathy Aversa Coleman.)

Maria (née Piacentini) and Louis Bonincontri are pictured above in a 1920s portrait with three of their seven children: John, Elizabeth, and Steve (the man at right is unidentified). The couple is also pictured at right in 1906 arriving in New York from Gambara, Italy, with three children: Julia, John, and Josephine. Virginia and Ida eventually completed the family. Around the 1930s, Elizabeth, the first beautician in Dundalk, opened Libby's Beauty Shop at 269 Baltimore Avenue. John and Steve worked at Bethlehem Steel. "It was very common for Italians to be barbers, all men," said Regina Dalmaso. "We started seeing women stylists in the 1970s. I had both a hairdressing and master barber license." Regina worked at her father Jon Dalmaso's salon, Jon Hairstylist, on Dundalk Avenue. (Both, courtesy Cooper DeLoach.)

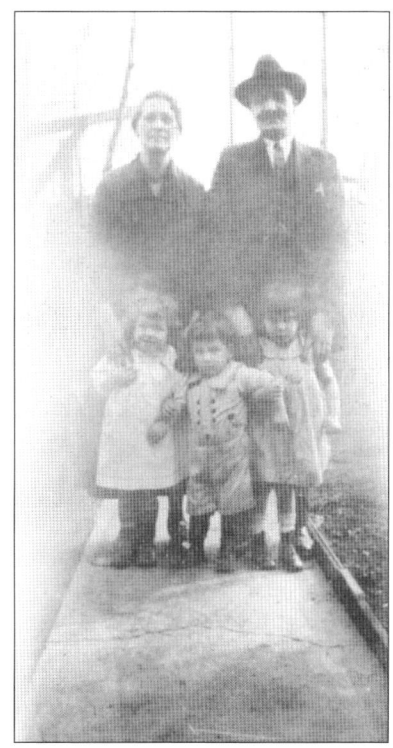

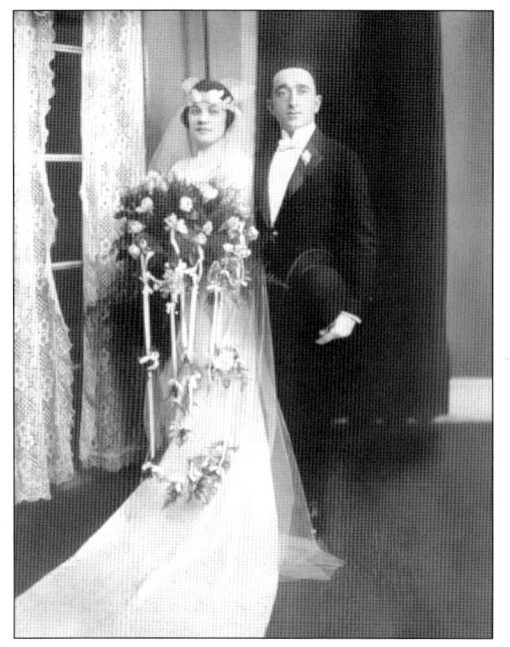

Francesco DiBattista and Pierina DiPietro, from Abruzzo, Italy, were married on October 29, 1922, at St. Leo's Church in Little Italy. The historic church was built in 1881 exclusively for Italian immigrants and continues to serve as the hub of Baltimore's Italian community. It has been home to several generations of families through baptisms, nuptials, and funerals; today, it attracts countless couples wishing to follow in their ancestors' footsteps by marrying there. St. Leo's is listed in the National Register of Historic Places. (Both, courtesy Rena DiBattista Cerquetti.)

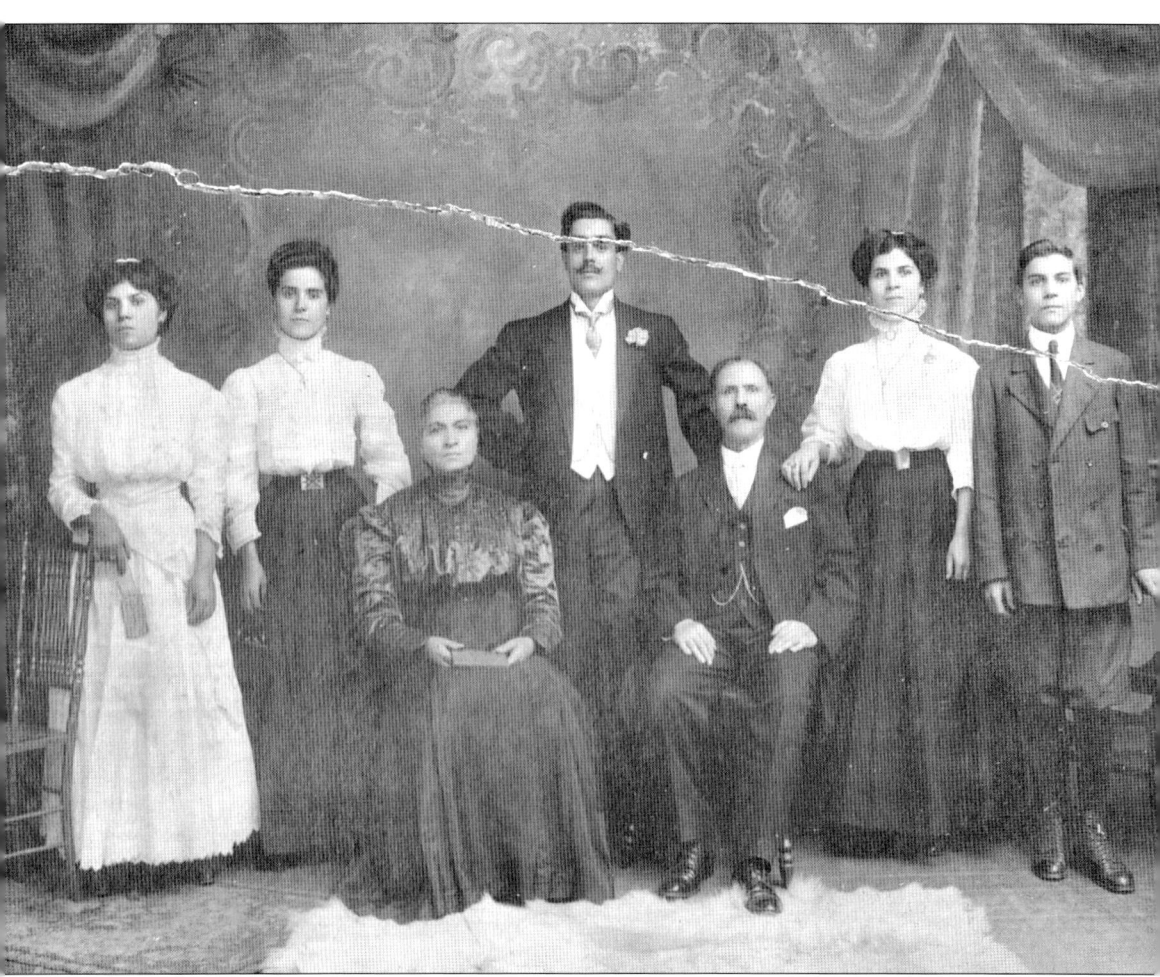

The Federico family, pictured here around 1910, hailed from Vallelunga Prataneno, Caltanissetta, in Sicily. Filippo Federico (seated) departed Palermo on the SS *Olbia* at age 45, entered the United States in New Orleans on July 10, 1900, and eventually moved to Baltimore. Six years later, his wife, Giuseppa Costanza (seated), and their children Giuseppa, Vincenza, Maria Stella, and Vincenzo left Palermo on the SS *Gerty*, which arrived at Ellis Island on June 28, 1906. Ellis Island was a place of great happiness as families reunited, but also one of great sorrow when some immigrants were found to be ill and forced to go back to Italy. The Federicos reunited with Filippo, who was already in Baltimore and residing at 1000 North Wolfe Street, where he was perhaps a shoemaker. Another son, Francesco, from Filippo's previous marriage, stands between the couple. (Courtesy Larry Martin.)

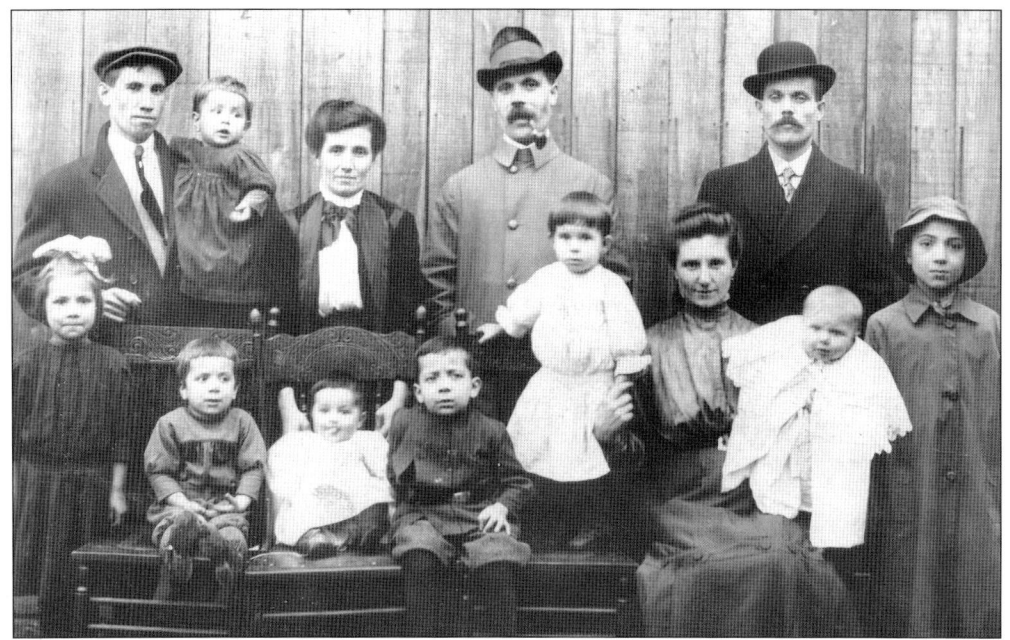

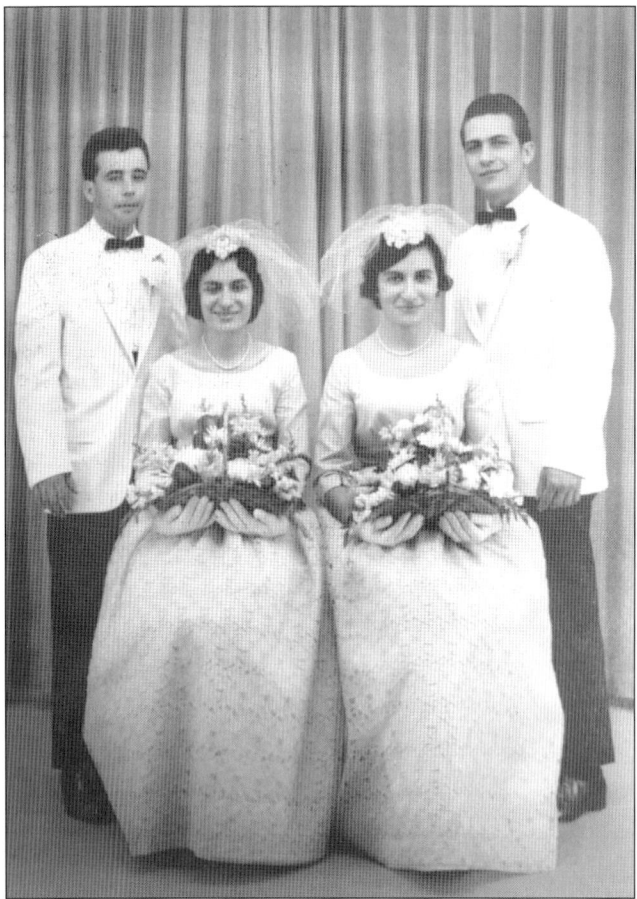

In the 1911 photograph above, in the back row are Abruzzese immigrants who came from Capracotta in the Molise region of Italy. From left to right in the second row are Giovanni Liberatore (holding a baby); Rosa D'Onofrio Liberatore and her husband, Savino Liberatore; and Giacomo Liberatore. The children were part of an eventual combination of 20 offspring between the couples. The woman in the front row is Antoinette D'Onofrio Liberatore (wife of Giacomo and sister of Rosa). Two sisters had married two brothers—a common occurrence in Italian families. In 1962, sisters Lucrezia and Concetta Battaglia had a double wedding ceremony in Cefalù, Sicily, when they married brothers Vincenzo and Giovanni Greco, as shown at left. (Above, courtesy Peggy Liberatore Castagna; left, courtesy Caterina Greco.)

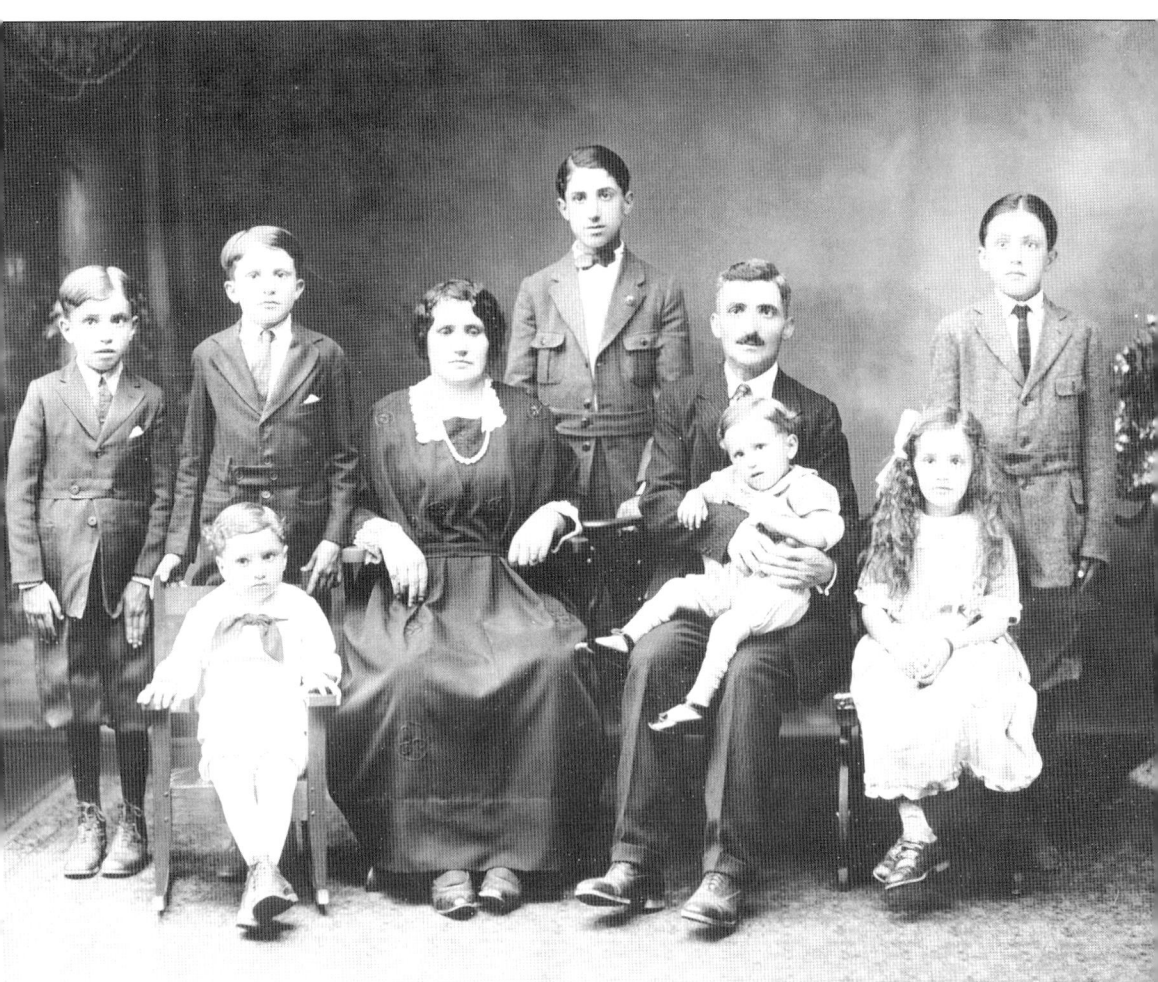

The Alessandri family is pictured in the mid-1920s. They eventually Americanized their last name to Alexander, most likely because of mispronunciation. "My paternal grandparents, Lorenzo and Theresa, came from northern Italy and departed Naples around 1919," said Larry Alexander, son of Lucy (née Dalessandro; her family was from Paduli) and Louis Alexander. "There were seven boys and one girl. The family settled in Yatesville, Pennsylvania, a very small town between Wilkes-Barre and Scranton. Most of the boys worked in the coal mines, some left to serve the country, others married and settled in that area. One uncle, Armando, moved to Baltimore in the 1950s to work at the Social Security Administration, as did I in 1959 to work there. I retired 52 years later. I am so proud to be Italian!" (Courtesy Larry Alexander.)

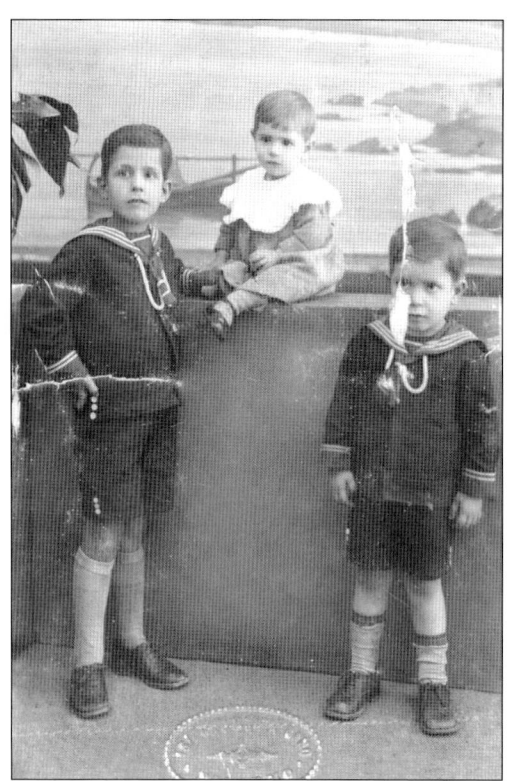

The 1931 postcard at left, stamped "Isidoro Montalbano / Palermo," shows Giovanni, Maria, and Giuseppe Scalia in Italy. Giovanni never came to the United States, Maria immigrated then returned, and Giuseppe (Joe) arrived in his early 20s and stayed. (Courtesy Scalia family.)

Guiseppe (Joe) Scalia and his bride, Philomena Cucco, are pictured at right on their honeymoon in 1951. They were an integral part of Little Italy, including its parish, school, bocce leagues, and Sons of Italy Lodge. Philomena is still active in the community; she and two of her four children still lived in the neighborhood when this book was published in 2020. (Courtesy Scalia family.)

Pictured at 410 South Eden Street in Little Italy in 1954 are a brother and sister from Vasto, Italy—Alfonso and Consiglia Tana. "*Zio* Alfonso would often visit my *Nonna* Consiglia's house for Sunday dinner," said Johnny Manna. "He and his brother, Carlo, were meticulous, dapper gentlemen, very well groomed. Both were active in the Italian Society and lived in a Washington, D.C. Italian neighborhood." The brothers owned a 19-chair barbershop in the prestigious Willard Hotel across from the White House. "*Zio* told me the story about when John F. Kennedy, then a senator, tried to instruct *Zio* how to cut hair. *Zio* replied, 'You take care of your politics, I'll take care of your hair.'" The Tana brothers came to America in early 1900 and soon after brought over Consiglia and their other sisters, Annina, Filomena, and Maria Nicole; one sister died from Spanish influenza. (Courtesy Johnny Manna.)

The 1939 wedding—held in Brooklyn, New York—of Olga Mossa of Luras, Sardinia, Italy, and John Bianchi of Baltimore included maid of honor Mary Pirisino (third from left) and flower girl Gina Mossa (née Molino; the author's *mamma*). The ringbearer was Michael Pirisino, and the groomsmen are, from left to right, Louis Bianchi, Nicholas Pirisino, Salvatore "Sam" Mossa (of Sardinia), groom John Bianchi, and two unidentified friends. The Bianchis, like many other New York Italians, relocated to Baltimore to join the already large Italian population settled there. They resided in the St. Helena neighborhood in Dundalk. (Courtesy Bianchi family.)

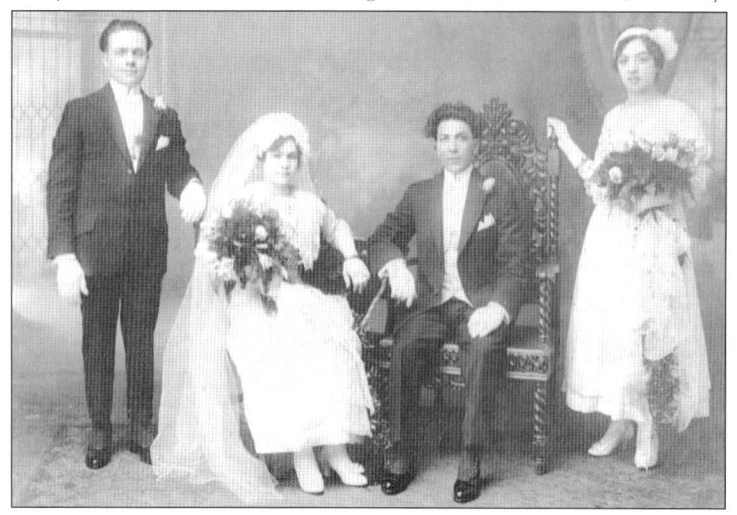

Italian immigrants Rosa Meo and Nicola Giro married on February 18, 1917, in St. Leo's Church. The maid of honor was Catherine Marino, and the best man was Nicola Santoro. (Courtesy Denise Giacomelli.)

In the early 1900s, Michaelangelo, Carmelo, and Giuseppe Panzarella came to Baltimore separately, as did their parents, Rosario and Michela, from Vallelunga Pratameno in Sicily. "All three brothers married women named Vincenzina," said Larry Martin, Michaelangelo's grandson. "Imagine how many times 'Which Vincenzina?' was asked!" Carmelo married Vincenzina Federico and had eight children; Giuseppe married Vincenzina Castrogiovanni and had none. At St. Leo's, Michaelangelo married Vincenzina Re, who bore six children: Theresa, Mary, Rose, Magdalena, Josephine, and Rosario. (Courtesy Larry Martin.)

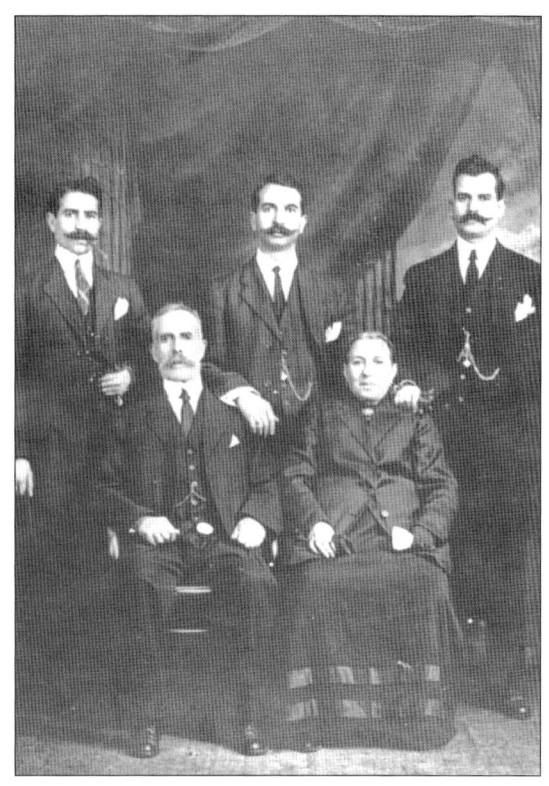

Michaelangelo Panzarella was widowed by age 43 but refused to put his children in an orphanage (two of them had died young), so he quickly married 27-year-old Maria "Mary" Buono (1889–1952), who had emigrated from Acquaformosa, Cosenza, Italy, in 1913. Mary (pictured) was listed in a 1922 Baltimore directory as a seamstress at 4 Biddison Lane, near Belair Road. (Courtesy Larry Martin.)

The Mossa brothers repetitively crossed the Atlantic Ocean between America and Italy as if the two countries were close to each other—surprisingly, since the voyage was long and not exactly a luxury cruise. Giovanni Mossa (far right; the author's *nonno*) came to the United States in 1913 at age 18. When he returned to Sardinia to visit his mother in 1928, he married Antonica Cabras before leaving for good in 1929. In Brooklyn, the couple had three children: Martino (holding the puppy), Rosina, and Gina (the author's *mamma*). Antonica did not visit her village again until 1964, to sell land and her house. Two of Giovanni's brothers, Salvatore "Sam" (second from left) and Antonio (second from right), settled in Dundalk, Maryland, as did Antonica after Giovanni died tragically young, having fallen from the roof of a soldier barrack while doing carpentry work at Aberdeen Proving Ground. Another brother, Mario (not pictured), returned to Sardinia to raise a family. (The man at far left is an unidentified friend.) Today, the Sardinian and Baltimorean Mossas maintain a strong connection using modern technology and have visited each other throughout the years. (Courtesy Gina Mossa Molino.)

A common aspect of Baltimore's Italian community is that it includes non-Italians, too. Many Russian Jews lived in Little Italy, and scores of other immigrants settled in Baltimore to form a merging of nationalities: German, Irish, Italian, Jewish, Lithuanian, Polish, English, and Chinese. Pictured around 1915 is a Hurwitz relative of Albert Sherman, an active volunteer for St. Leo's Church when this book was published. In 1905, his father, Hyman, had arrived in the United States with his parents and a sister; they lived on South Eden Street and then East Pratt Street. Hyman's five siblings arrived separately between 1891 and 1905. One (Morris) owned a ladies' tailor shop in his home at 217 South Central Avenue. Around 1920, Albert's ancestors had moved to other parts of Baltimore. (Courtesy Albert Sherman.)

Mary DellaFera and Joseph Montcalmo were married in 1932 in Wilmington, Delaware. Although he was born in 1908 in the United States, at age two, Joseph returned to Giusvalla, Italy, with his parents and then came back to the United States three years later. Mary was a first-generation Italian American and the oldest of nine siblings. In the early 1900s, the couple's families were part of a migration of textile workers from Italy to New York City, Wilmington, and Baltimore. Mary and Joseph's son Anthony Montcalmo grew up in Wilmington's Little Italy and was still active in Baltimore's Italian community when this book was published in 2020. (Courtesy Anthony Montcalmo.)

This c. 1941 family portrait of the Dell'Uomo *famiglia* includes, from left to right, (seated) Giovanna and Nella (née Gonella); (standing) John, Maurizio, and Joseph. (Courtesy Jean Dell'Uomo Kelley.)

This 1905 image of the Romaniello family from Montella, Avellino, Italy, shows Giuseppe (born in 1879) and Rosa (née Dello Buono; born 1877) with 2 of their 10 children: baby Salvatore (born in 1904) and Charles (born in 1901). The couple immigrated in 1903 and later had Mary Liberta, Anthony, Lena, Margaret, Phillip, and Rose. They lost a stillborn baby and a one-year-old child to a gastrointestinal infection called "Summer Complaint." (Courtesy Rose Prince Jackson.)

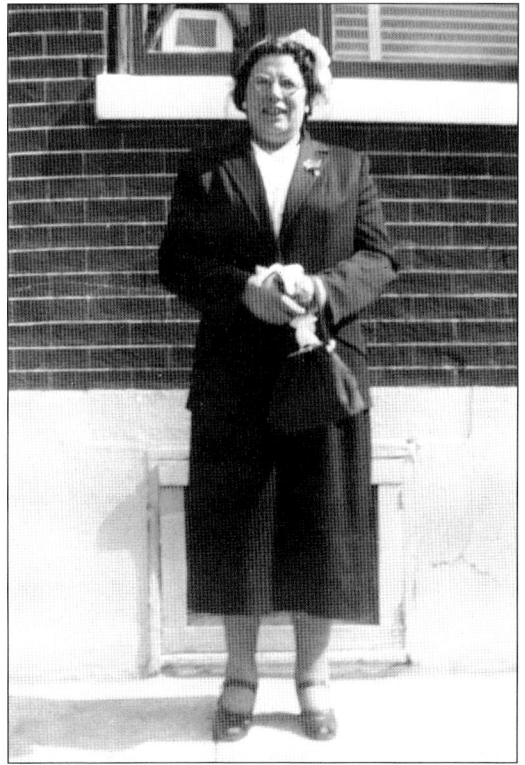

Antonietta Cucco (née Manente) arrived from Naples, Italy, in 1926, following her husband, Vincent Cucco, who emigrated in 1921 from Santa Maria di Castellabate. The couple resided at 915 Stiles Street in Little Italy, where Vincent was a master tailor. They had four children: Philomena (married Joseph Scalia), Giovanna "Jennie" (married Leonardo Scaffidi), Eleanora (married Harry Stein), and Frederick (married Opal Whittemore). Today, Eleanora still resides at 915 Stiles Street, and Philomena lives next door. (Courtesy Scalia family.)

The certificate of naturalization had not changed much between Bruno Lioi's in 1930 (above) and Antonica Cabras Mossa's (the author's *nonna*) in 1998 (below). Mossa acquired hers at age 88 although she immigrated in 1929. Today, many descendants of Italian immigrants have applied for dual citizenship. "Lately we see more people asking how to obtain it, driven by a sense of pride and a need to reconnect with their ancestors' heritage," said Mauro Dal Bo, Italian honorary consulate, Baltimore. (Above, courtesy Lioi family; below, courtesy Mossa family.)

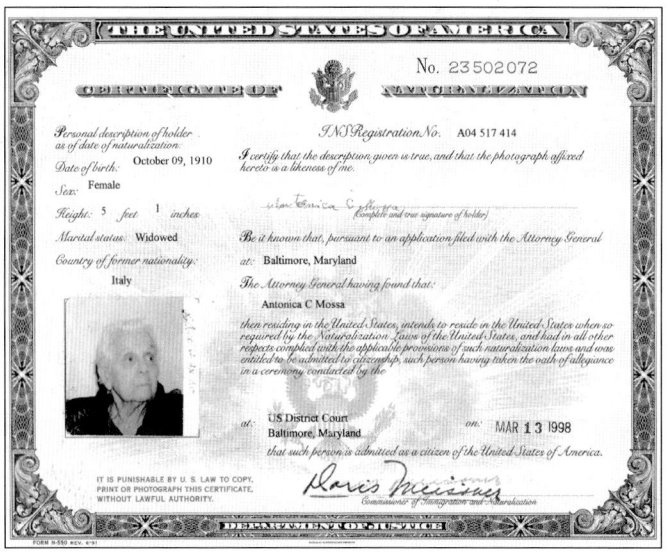

Anthony Prince, pictured in the 1930s, was one of three brothers (with Vito and Charles) who grew up in Little Italy at 403 South Central Avenue with their parents, Maria Antonia (née Di Matteo; born in 1882 in Altavilla Silentina, Salerno) and Antonio Prinzo (born in 1877 in Felitto, Salerno; surname later changed to Prince). Anthony and Vito formed Prince Brothers, a brick contractor in Baltimore. Later, Anthony served as secretary to Mayor Thomas D'Alesandro Jr. while Theodore McKeldin was governor. Two of the Prince brothers married two Romaniello sisters: Margaret (to Anthony) and Rose (to Vito). Charles, who was single at age 24, was murdered on New Year's Eve in 1927 at 1222 Bank Street, where he was shot in the head on his way to play cards. "It was during Prohibition," said Rose Prince Jackson. "My father Vito said Charles knew too much about what was going on at the docks with liquor being brought into the city, so they killed him. He knew the man found guilty was not the murderer and knew the man who ordered the hit." (Courtesy Rose Prince Jackson.)

This 1942 alien registration booklet belonged to Maria Rosaria Addino Lioi, born in 1894 in Sant'Andrea, Catanzaro. She lived on Pratt Street in Little Italy with her husband, Bruno, and their six children: Catherine and Andrew, who immigrated with Rosaria in 1930, and Theresa, Paul, John, and Gerard "Jerry," who were born in the United States. At publication, Andrew and Jerry remained active in the Italian community. "My mother was interrogated at Fort Holabird," said Andrew, "but not intimidated." Her card was updated annually via the FBI. (Courtesy Lioi family.)

Theresa Marie Corasaniti of Davoli, Calabria, was a 4-foot, 11-inch Italian born in 1862 who lived at 204 North Port Street. Theresa's great-granddaughter Cathy Aversa Coleman said Theresa signed her alien registration booklet with an "X" since "she didn't read or write and never learned English—she refused! I come from a long line of tough women!" The booklet was equal to today's Green Card issued by US Citizenship and Immigration Services. (Courtesy Cathy Aversa Coleman.)

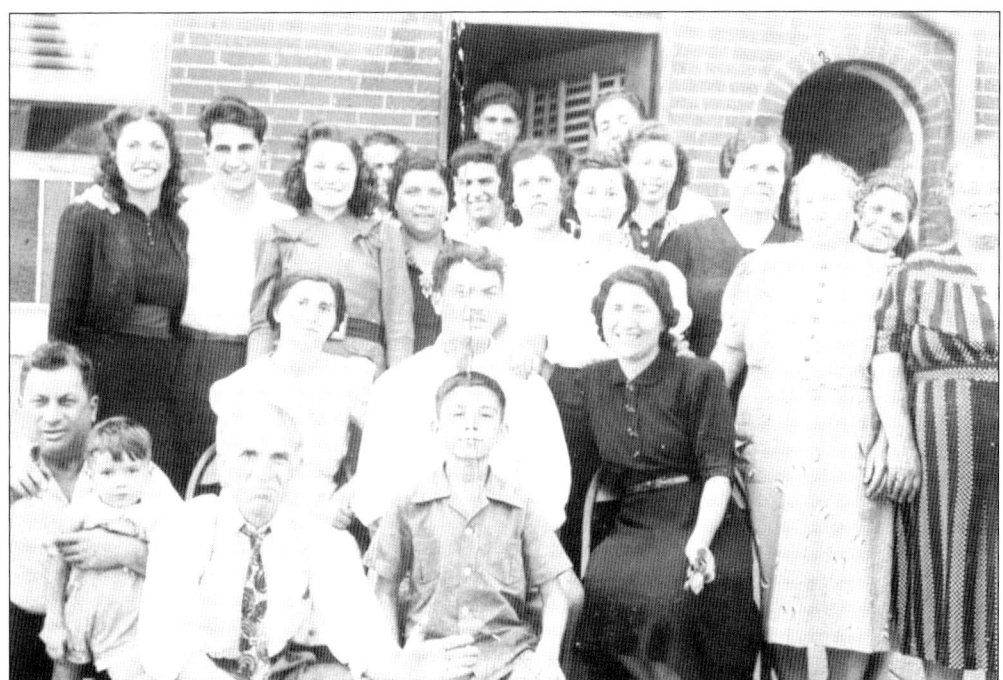

Gathered at 410 South Eden Street in Little Italy in 1940 are family and friends of two-year-old Johnny Manna (left) on his baptism day, including his godfather Domenico Delnuto from Vasto, Abruzzo (holding Johnny), and Johnny's brother Saverio Manna (front). "I walked to St. Leo's that day," Johnny remembered. He was not baptized right after birth because his immigrant parents, Patsy and Mary (seated), waited until their family could travel from Brooklyn, New York. (Courtesy Johnny Manna.)

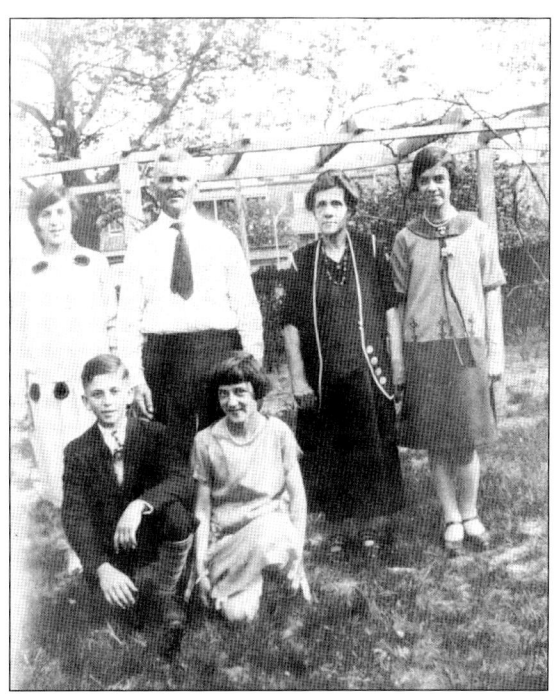

In 1881, Margherita Schiavetti and Domenico Foglio emigrated from Frosolone and Carpinone (provinces of Isernia), Italy. Domenico was a bricklayer who helped build St. Leo's, which is where he and Margherita were married in January 1888. The spelling of their last name was later changed to Folio. They had eight children and resided in Little Italy. The couple is shown with four of their grandchildren; pictured are, from left to right, (first row) Francis "Bud" and Marie Tosches; (second row) Congetta "Jetta" Tosches, Domenico and Margherita, and Catherine "Kay" Tosches. (Courtesy George M. Folio and Ruthie Folio Robinson.)

Pictured around 1918 on Eden Street in Little Italy are the Tana sisters, Maria "Mary" and Gina "Jean" from Vasto, Abruzzo. (Courtesy Johnny Manna.)

Two
GROWING UP ITALIAN

Italian playmates sit on the steps of St. Leo's School in Little Italy. "Our neighborhood is one of the most colorful in Baltimore's history," said Will Matricciani, who grew up in Little Italy and is still active in its Italian community and parish. (Courtesy Carmen Strollo.)

This c. 1915 postcard photograph was taken in Atlantic City, New Jersey, a popular destination for Baltimoreans, and shows Savino Liberatore (left) with a *paesano*. Italians also visited beaches in Wildwood, New Jersey; Ocean City, Maryland; and local spots such as Kurtz Beach, Bayshore, and Tolchester Beach. (Courtesy Peggy Liberatore Castagna.)

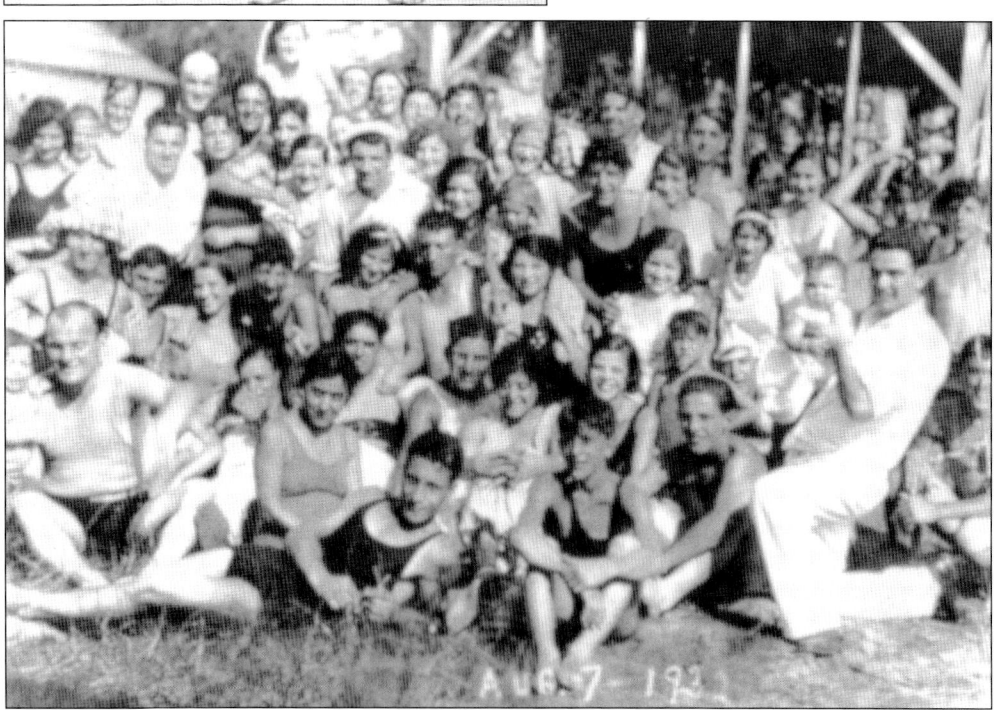

Little information is known about this photograph taken in the heat of a Baltimore summer on August 7, 1932. If the happy faces on this cheerful group of over 50 friends and relatives is any indication, they were probably relaxing on a weekend afternoon at a beach or pool. (Courtesy Frank Cossentino.)

Because Ellis Island was the entry point for ships from Europe, multitudes of Italians began their American lives in New York City. Almost two million Italians arrived in the United States between 1900 and 1914. By 1930, New York City was home to over one million Italian Americans; others were spread across the United States. Pictured here in Brooklyn in 1939 in what is believed to be a Studebaker is Antonica Cabras Mossa (the author's *nonna*) from Luras, Sardinia, Italy, with her children, Gina (left; the author's *mamma*), Rosina (beside Gina), and Martino (in the car). The Mossas relocated to Baltimore to join relatives. (Courtesy Gina Mossa Molino.)

Johnny Barnett clutches a stuffed bunny on Easter 1942 in front of his grandfather's Panzarella Shoe Service on Harford Road. His mother, Rose Panzarella, was a daughter of immigrant Michelangelo Panzarella. "Immigrants were so poor, few could afford new shoes," said Larry Martin, "so they had their shoes repaired. I remember my parents getting new soles and rubber heels put on my shoes." (Courtesy Larry Martin.)

Around 1945, Rose Mary Prince sits in a baby stroller on Bank Street near her grandparents' store, Romaniello's. Her parents were Margaret (née Romaniello) and Anthony Prince. Her grandfather Antonio Prinzo was killed in 1907 while working on the rails in Union Tunnel on Bond Street. As he and two coworkers waited for the *New York Express* to pass, the tunnel filled with steam. The conductor of a working train failed to see the workmen and backed up over them. (Courtesy Rose Prince Jackson.)

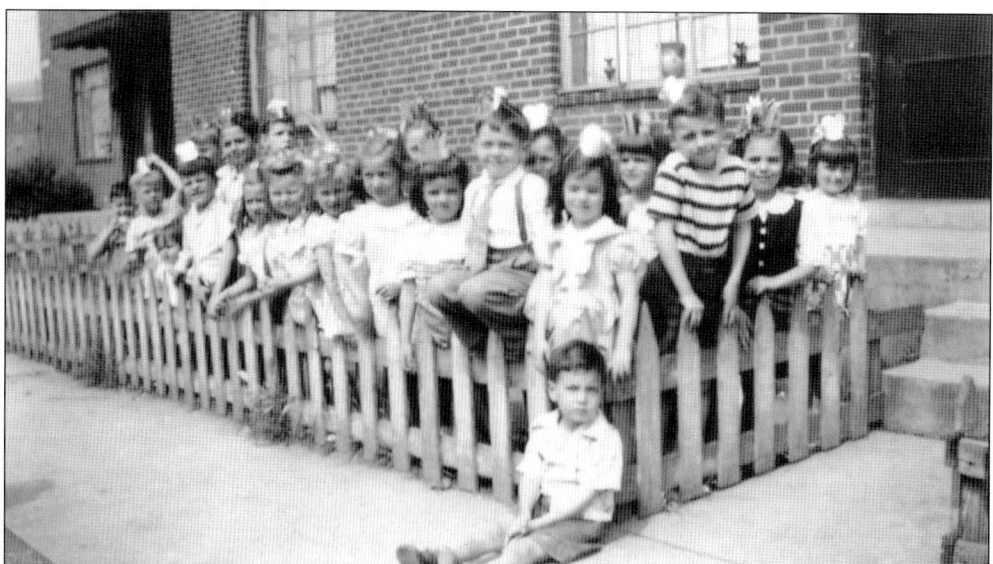

This 1949 children's party was held at Perkins Projects, a subsidized housing complex east of Little Italy; the complex was demolished in 2019. "We had to leave when my father made too much money," said Gary Molino (pictured seated), who grew up on Eden Street. "Aunt Mary LaRosa [née Culotta] and her family lived there, too. It was all white, but not all Italian, and offered a community center for us kids to play." (Courtesy Gary Molino.)

An Italian kitchen is the greatest place to be! Pictured at right in the kitchen of Olga Bianchi (née Mossa) in 1947 are, from left to right, John Dalmaso (holding Celeste, one of his four daughters); his wife, Mary (née Pirisino), holding their daughter Bonnie; Mary's mother (and the girls' *nonna*), Amelia Mossa; cousin Angelina Bianchi; and another Dalmaso daughter, Regina. (Helen is the fourth daughter.) The kitchen is the hub of the home for Italian families. "I live in my kitchen," said Regina Dalmaso Garey, "and every Sunday for years, hosted my children and whoever else showed up. I cook and bake often—I love it—and learned from *Nonni* Pirisino. I helped her make gnocchi and ravioli as she sang opera." The below photograph shows the Battaglia family around the table in 1955: Vincenzo, Salvatore, parents Cosimo and Maria (née Elardo), Concetta, Lucrezia, and Antonio; Giuseppe is not pictured. (Right, courtesy Victoria Bianchi Santopietro; below, courtesy Caterina Greco.)

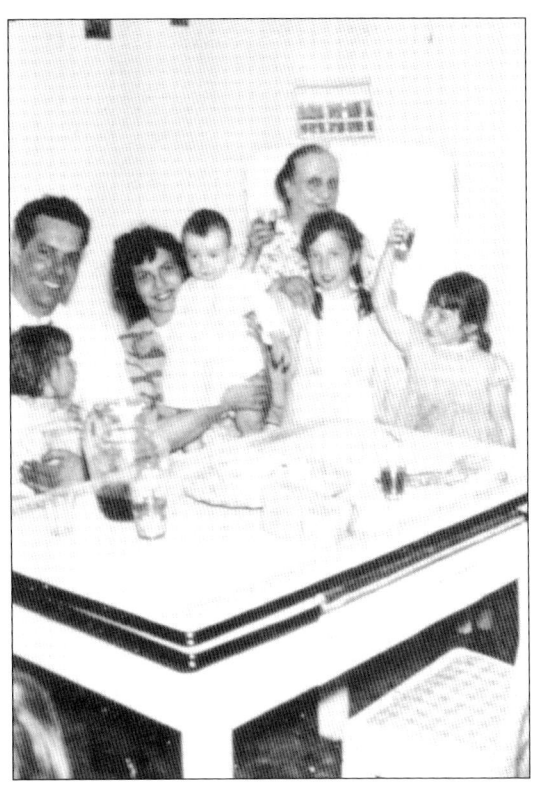

On December 23, 1962, a Christmas celebration was held for parish families in St. Leo's Church Hall, which has been the site of hundreds of events over the decades: bake sales, pizza dances, dinners for the homeless, church council meetings, family celebrations, St. Joseph Tables, and many more. (Courtesy Denise Giacomelli.)

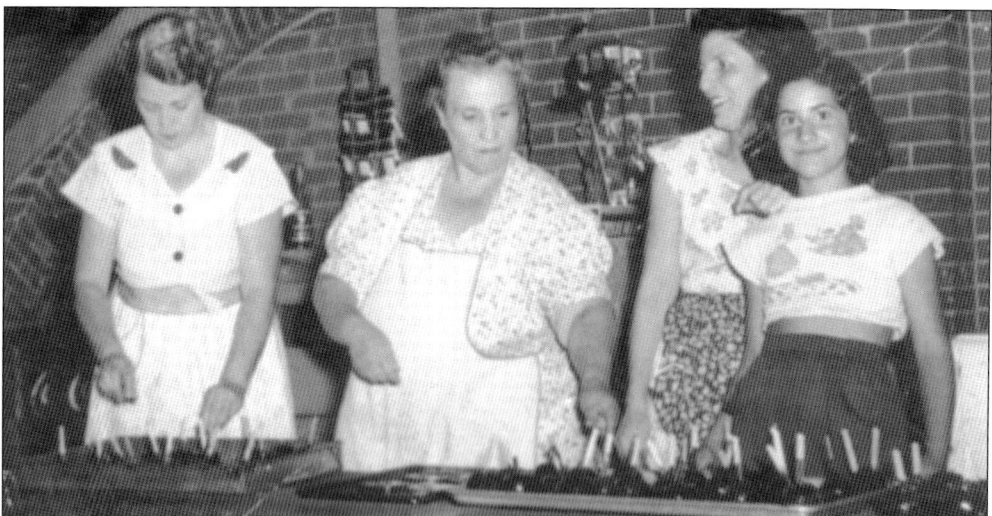

"We called them sticky apples," said Charlie Terzi about the treats for sale in front of St. Leo's. Believed to be pictured are, from left to right, Margaret Petrella, Clara Platerote, Florence Romeo, and Maryann D'Amico Blattermann. "Made with molasses," said Giovanna Aquia Blattermann; "Mr. Marino made and sold them for five cents every fall," as did Mary Flamini. "Red and caramel," said Mary Otto. "I remember going in her basement to buy them." (Courtesy St. Leo's Church.)

In the 1964 photograph above, the Giacomellis—from left to right, Rolando, Evelyn, Reneé, Anna, and Denise—of Gough Street in Little Italy are ready for travel to Prato, Italy, to visit relatives. At age 25, Rolando arrived in Maryland in 1945 with the Italian Navy as a prisoner of war held by the US government at Camp Meade. He met and married his wife, Anna Giro, of Little Italy, during a dance for Italian soldiers and remained in the United States. In 1962, Denise, age 9, accompanied her father to Prato. Note that her photograph and information were part of her father's passport. It was—and is—common for Italian Americans to visit family in Italy. Although raised by Italian parents and grandparents, the Giacomelli sisters were not taught the language—typical for offspring of immigrants who preferred to learn English and blend into American life. (Both, courtesy Denise Giacomelli.)

In 1945, on Baltimore Avenue in Dundalk, Amelia Mossa (née Fabbri; 1881–1956) from Modena, Italy, poses with her granddaughter Angelina, who was five at the time. "It was wonderful to be in an Italian family," said Angelina Bianchi Womack. "It brings tears to remember those fantastic days. Our gatherings were around spectacular Italian food: homemade ravioli and lasagna, delicious chicken in wine sauce, and on special occasions, a New York relative drove down with a huge container of snails which were thrown in the tomato sauce. My parents, *Nonna* Amelia, and my three sisters ate the snails out of their shells. Our meals were 'different' from American meals; we started with pasta and ended with salad. *Nonna* always wore a flowery dress under a white apron; she smiled so much! She and my mother Olga had the most loving relationship. I think of that when I am with my daughter Lisa." (Courtesy Bianchi family.)

On Leonardo Scaffidi's christening day around 1927, he was held by his godfather and uncle Cono Spinella, as shown here. Leonardo was born in 1926 in a Little Italy house while his parents, Rosa Spinella and Cono Scaffidi, were visiting from San Giosa, Messina, Sicily. They had eight children: Joseph, Maria, Leonardo, Catherine, Josephine, Rosa, Sarina, and Cono. The family returned to Italy. In 1948, at age 21, Leonardo immigrated to the United States as "Leo." He married Giovanna "Jennie" Cucco, and they had five daughters: Rose Mary, Antoinette, Catherine, Christina, and Angela. Leo provided for his family as a master barber and owner of Eastern Barber Shop for 25 years. "He loved serving people and would not accept payment during a house call to a customer too ill to go in for a haircut and a shave," said Christina Scaffidi Wohlfort. "His family was poor, and he had only a third-grade education, yet he was the smartest man I knew." (Courtesy Christina Scaffidi Wohlfort.)

In the early 1960s, seven students from Yeager's Music on Eastern Avenue were invited to play their instruments for Lawrence Welk (in raincoat), a famous musician, accordionist, bandleader, and television show host, upon his arrival at Friendship Airport (now Baltimore Washington International). Tommy Panto (fifth adult from left) was their instructor at Yeager's. On accordion in the front row are, from left to right, Johnny Castagna, Dianne Winiecki, and Rody Bartholomew; Bill Hathaway is playing the drum. (Three other accordion players in the back row are unidentified.) At left, Johnny, at age 12, holds his accordion at 1011 Stiles Street in Little Italy. He played professionally into the late 1980s and still plays today as a hobby. (Both, courtesy Peggy Liberatore Castagna.)

These Italian cousins are shown playing outside in 1962. Pictured are, from left to right, Antoinette Scaffidi, Antoinette Scalia, Rosemary Scaffidi, Libby Cucco, and Rosalia Scalia. "Cousins are our sisters and brothers that we may or may not see every day, may or may not live with," said Christina Scaffidi Wohlfort, "yet either way are essential to making Sunday dinners sacred in *la famiglia*." (Courtesy Scalia family.)

This nursery school graduating class of 1949 is pictured in the 100 Block of South Broadway in Fells Point. "Mrs. Frances Muller taught there," said Bill Butler. It was most likely Catholic, since "they had a Blessed Mother statue," said Gary Molino, then almost age five, who attended the school with his sister Carol Ann (their third sibling is Johnny Wayne). (Courtesy Gary Molino.)

In this c. 1946 photograph, Regina Dalmaso is being held by her grandfather Angelo Dalmaso on Baltimore Avenue in the St. Helena neighborhood of Dundalk. Angelo was born in Austria, which, in that era, housed many Italians and Germans. St. Helena predominantly consisted of Italian residents. Victoria Bianchi Santopietro, Regina's cousin, said, "Riding my bike down the street, I remember hearing people speaking Italian." (Courtesy Santopietro family.)

Luigi Molino (the author's grandfather) from Vasto, Abruzzo, is pictured in 1952 in front of his 2316 East Fayette Street house and shoe repair shop with his grandson Raymond Schaeferbein. Luigi lived with his wife, Annina (née Tana, also from Vasto), and their children Matilda, Jean, John, Louie, and Joseph, among a rotating spindle, brushes, grinding wheels, hammers, leather punchers, glue, and cast-iron devices that held shoes in place. Luigi sometimes read comic books to help teach himself English. (Courtesy Schaeferbein family.)

Above, Anthony Kaiser celebrates his first birthday with his mother, Sarah LoPresti Kaiser, in *Nonna* Grace LoPresti's kitchen in Baltimore City in the early 1950s. "We had a big Italian family, as most did back then," said Anthony's sister Janet Kaiser. "Lots of good memories. The traditions—and the food! I wish I had some of those recipes, especially for this Italian cream cake—the biggest I've ever seen. Italians really like their cakes and pastries!" Janet is pictured at right in the late 1950s with *Nonna* Grace at Sarah and John Kaiser's house in Rosedale. Grace's sons, Nino and Joe, owned LoPresti's butcher shop and grocery store on Stiles Street in Little Italy. The family lived upstairs. (Both, courtesy Janet Kaiser.)

A typical Italian kitchen had a table laden with food and wine and *la mamma* serving her children, hardly sitting down herself to *mangia* (eat). The apron on Philomena Scalia was the "standard uniform" for Italian housewives, who wore them all day over their dresses. They sewed new aprons out of worn men's shirts, dresses, and housecoats. "My grandmother made aprons," said Tina DeFranco, daughter of Sicilian immigrant Nino Cricchio, and "I still wear one when cooking." Paulie Morisi said his "*Nonna* wore an apron like this while she made homemade tortellini. It was passed on to my mom, who passed it to my sisters." His *nonni*, Frank and Madeline Morisi, lived in Little Italy on President Street around the 1940s. Italian recipes were passed down to daughters and granddaughters, mostly by demonstration but sometimes on paper—if a recipe was written at all. "When *Nonna* had on her apron," said Anna Vitale Lybrook, "we knew we were in for a delicious treat. She was amazing at cooking and baking." (Courtesy Scalia family.)

The LaRosa, Molino, and Cappolloni families are shown enjoying a day at Rocks State Park in 1952. "It was free and a nice place to go to escape the city and summer heat," said Gary Molino, son of Angela (née Culotta) and John "Jay" Molino of Little Italy. "Italians not only lived together, we socialized outside of the neighborhood." Fair View Beach in Pasadena, Bay Ridge Beach in Annapolis, Rocky Point, and Patapsco State Park were other popular venues. "We went to Bay Ridge in the late '50s and early '60s. It had a beach, pool, legal slots, a baseball field, and pavilions where they hosted company picnics." (Courtesy Gary Molino.)

From left to right are "my mother Theresa Martin and two of her four sisters, Rose Barnett and Mary Ragan [the other sisters were Lena and Josephine]," said Larry Martin. "They were 'the Panzarella Girls.' Aunt Lena was the only sister who married an Italian. My mother told me when they were trying to meet boys, they dabbed Parmesan behind their ears to attract Italians." (Courtesy Larry Martin.)

Michelangelo "Angelo" Panzarella (with his daughter, Theresa, in 1944) arrived in America with $15 and the clothes on his back. While hunting for his grandfather's birth record in the tiny village of Vallelunga Pratameno, Sicily, Angelo's grandson Larry Martin watched a clerk turn pages of a dusty old book. "Here's a Pansarella! Michelangelo, born November 8, 1879!" he said. "There was the original spelling, and the record included the names and address of my great-grandparents. I felt excitement, joy, a connection bridging my mother to her father, and wonderment about his life in that village, and why they wanted to leave for another world so far away. I was in awe knowing he had walked those streets 100 years before." (Courtesy Larry Martin.)

46

"I made my First Holy Communion in second grade as a class at St. Leo's," said Rosalia Scalia, who was still a resident of Little Italy at the time of publication, "with William Matricciani, Franny Cippoloni, Darlene Biscotti, Daniel Brotto, Peter Iacovelli, Theresa Delorenzo, Bernice Harris, Pat Giorgilli, and others. I remember I was sick with the mumps and had to miss the Communion ceremony! Since several others also had the mumps, a few Communion Masses took place." (Courtesy Scalia family.)

A 1962 Confirmation group of third-graders files out of St. Leo's Church after being confirmed by Bishop Lawrence Shehan (who later became a cardinal). The girls pictured are, from bottom to top, Susan Culotta, Lillian Tomasina, Marcia Caltabiano, Denise Giacomelli, Sally Serpise, and Kathleen Rose. The boys are, from bottom to top, George Tutor, Thaddeus Miller, Anthony Ortiz, unidentified, John Thurman, and unidentified. At ages 8 to 9, "we were the youngest to be confirmed," said Susan Culotta Morris. (Courtesy Denise Giacomelli.)

In this c. 1941 image, brothers Gino (in stroller) and Vincent DePalmer play outdoors in Little Italy near 914 Fawn Street, where their grandparents Rosa and Vincenzo Gentile lived. (Courtesy Kimberly DePalmer.)

Carmen Strollo is being held by his *nonna* Rosa Quintilliani (née Ianni) in 1957 at 909 Stiles Street. Rosa arrived from Casalvieri, Italy, in 1914 following her husband, Pasquale, who came in 1907, and they had seven children: Carmel, Tony, Danny, Julian, Josie, Kay, and Rose. "We lived in a converted hotel in four apartments: my grandmother, parents, godparents, and uncles," said Strollo. "My grandmother helped raise me and didn't speak English, but definitely got her message across when she meant business!" (Courtesy Carmen Strollo.)

Three

ITALIANS AT WORK

Amadeo Liberatore, a first-generation Italian American (pictured here in 1940), worked an East Baltimore postal route as a mailman for 33 years from a branch on Milton Avenue. His brother Sam Liberatore and cousin John Liberatore followed in his footsteps and also worked for the US Postal Service. (Courtesy Peggy Liberatore Castagna.)

Federico's Shoe Store on McElderry Street was owned by Mary Federico (née Giordano) from Cefalù and Francesco J. Federico Sr. from Vallelunga Pratameno, who are pictured above in 1924 with their sons Frank Jr., Anthony Sr., and Philip Sr., as well as an unidentified employee. "Frank Sr. was a bootlegger during Prohibition and made whiskey on the third floor; the family lived on the second," said Phil Federico, a grandson of Mary and Francesco. "My grandfather hid the alcohol in the shoeboxes and sold many shoes. He never got caught; however, once, when his boys were transporting a whiskey barrel, they were pulled over by a cop and chased. My father, Tony, got away, but my uncles were arrested and convicted." Philip and Frank (the bartender pictured below in 1934 with patrons) turned the shoe store into Rico's bar and package goods store, eventually relocating it to Gay and Preston Streets. (Both, courtesy Phil Federico.)

John F. Liberto Sr. operated a fruit and vegetable stall for over 50 years in Lexington Market with eight other Italian produce vendors. His father, Salvatore Liberto, from Cefalù, Sicily, established the business in 1890 and passed it to John (one of five Liberto brothers, along with Joseph, Frank, Mello, and Pete) in 1950. John Jr. had worked there part-time since age 12 but "hated it," he said. "I missed out on hanging with my friends—not a priority for Italian Americans who owned businesses. Yet the work ethic I learned was priceless." (Courtesy Liberto family.)

Mario Scilipoti (pictured in 1950) was an immigrant from Bafia, Sicily, and owned Mario's Barber Shop at Pratt and High Streets. His son, Tom "Mazzie" Scilipoti, followed in his father's footsteps, with a shop in his Bank Street home boasting the classic spinning barber pole in front. A retired professional photographer, at age 90, Tom was still active in the Italian community and shooting pictures of its events, processions, and Masses at the time of this book's publication. (Courtesy Thomas C. Scilipoti.)

Rosa Ponselle, the first American-trained opera star and a daughter of Italian immigrants, was one of the world's leading sopranos during the 1920s and 1930s. She lived in an Italian-style villa in Greenspring Valley between 1940 and 1981; her father-in-law, Howard Jackson, was a former Baltimore mayor. Ponselle was artistic director for Baltimore Opera Company for three decades. "Anyone who was culturally connected adored Ponselle. I've never heard a voice like Rosa's," said Elayne Duke, whose mother was Rosa's "dear friend." (Courtesy Lester Dequaine Collection on Rosa Ponselle, Peabody Institute Archives.)

Chiapparelli's, the oldest restaurant in Baltimore's Little Italy, was initially opened as a bakery by Pasquale "Patsy" Chiapparelli (1899–1975; center) in the 1920s at 237 South High Street. It became an Italian restaurant in 1940. Patsy came to America in his 20s from Naples, Italy. He and his wife, Nellie (née Annie Pizza), had four sons born in the United States; from left to right are Nicky (also shown baking bread at right), Charlie, Louie, and Buddy. Patsy produced some of the first "pizza pies" in Baltimore. Pizza and other flour-based products, such as ravioli, gnocchi, and Italian bread, are still made in the restaurant's basement. Patsy's grandson Bryan Chiapparelli is now the proprietor and has worked at the restaurant since 1995 after graduating college; he is a Little Italy resident. His mother, Kit Chiapparelli, also works there. (Both, courtesy Bryan Chiapparelli.)

53

Born in Baltimore in 1907 as the son of immigrants from Chieti, Abruzzo, Francis Guerrasio worked as a Baltimore City Police patrolman (and later a sergeant) from 1939 to 1954. Married to a 100-percent Irish girl, Alverta Neary, Francis shortened his name to Guerras "to please his mother-in-law who was not fond of Italians," said his grandson David Welk. Francis had 15 siblings and attended St. Mary's Industrial School for Boys with several brothers after their father died and their mother could not manage so many children. Francis was active at St. Elizabeth's Church in Highlandtown and a member of its Holy Name Society. (Courtesy David G. Welk.)

In this 1951 photograph, a worker makes spaghetti as it leaves a hydraulic press, ready to be stretched onto sticks to dry. (Photograph by A. Aubrey Bodine; copyright © Jennifer B. Bodine.)

Pictured here in 1951, Oscar Alladino "Dino" Martello, born in 1906 in the United States, had moved to Pinzolo, Italy, as a child and returned to Brooklyn, New York, in 1926. In 1929, Dino moved to Baltimore with his wife, Firma, and their children; there, he established Martello Brothers Knife Service. As the business grew, Dino's brothers Guido, Cornelio, and Pietro emigrated and learned the trade, operating the business from a truck with a gas engine grinding wheel inside it. They primarily sharpened cutlery for restaurants and butchers; however, neighbors asked to have household items sharpened, too. Dino's son John took over the business. Today, a third generation of Martellos has expanded to selling and servicing food equipment and supplies in multiple states. (Courtesy H. Martello family.)

In the 1950s, Rolando Giacomelli, an immigrant from Prato, Italy, opened Eastern Car Wash at 6828 Eastern Avenue, and he operated it for 40 years. Although he sold the business in the 1990s, it is still open under the same name; until 2019, it still had one of its original employees, Lena Williams. The building's facade is still intact as pictured. (Courtesy Denise Giacomelli.)

Above, Joe LoPresti holds baby Grace in front of his butcher shop, which he owned with his brother Nino, at 919 Stiles Street. Joe and his wife, Gemma (née Pompa), had two other daughters, JoAnn and Madeline. "LoPresti's had everything you could want," said Joe and Nino's niece, Janet Kaiser, "fresh meats, sausage, cheese, bread, olives, and groceries. As a young girl, I enjoyed looking at the items behind the refrigerated glass. Walking in, you could smell the cheese and hear customers speaking Italian." Apicella's butcher shop and grocer was opened in 1949 on the corner of Stiles and High Streets by Eleanor (née Lancelotta) and Alphonse "Al" Apicella, the son of Italian immigrant Anthony Apicella. Al Apicella is pictured at left in the below image (with Joe LoPresti at right). Apicella's was in business for 30 years; its location was previously home to Vaccarino's Grocery, which was established in 1919 by Isadore and Rose Vaccarino. (Above, courtesy Will Matricciani; below, courtesy Apicella family.)

Book covers provided to St. Leo's School students advertised local businesses such as DiLiello's Insurance, which has been in Little Italy since 1949. Pastore's, established in 1898, has been family-operated for five generations. Frank Della Noce funeral home was in an 1860 building and established by Frank, who immigrated in 1911. Kelly & Poggi was founded in 1860 by a non-Italian (Dr. Thomas Kelly) and taken over in 1913 by immigrant Gabriel "Gabe" Poggi, who became one of Baltimore's top pharmacists. His daughters, Julia and Mary, later transformed it into a soda fountain and store. (Courtesy Will Matricciani.)

KELLY & POGGI
℞ "WHERE PHARMACY IS A PROFESSION" ℞
Phone: BRoadway 6-6085
EXETER & FAWN STS. BALTIMORE

2905 MOUNTAIN ROAD 8645 LOCH RAVEN BLVD.
PASADENA, MD. 21122 TOWSON, MD. 21204
PHONE: 255-8822 PHONE: 828-9656

PASTORE, INC.
IMPORTED AND DOMESTIC
Italian-American Groceries
Distributors for Silver Star Ravioli - Manicotti - Cavatelli
1007 E. LOMBARD STREET 3217 BELAIR ROAD
BALTIMORE, MD. 21202 BALTIMORE, MD. 21213
PHONE: 732-9643 PHONE: 327-4315

Open Mon., Tues. & Thurs. until 5 — Saturday until 1
Wed. & Fri. Evenings until 9

MICHAEL F. DI LIELLO
ALL FORMS OF INSURANCE
410 SOUTH HIGH STREET
Office Residence
727-5504 444-9421

FRANK DELLA NOCE
FUNERAL HOME
A Beautiful Modern Home for the Use of Patrons
at No Extra Cost
Completely Air-Conditioned

HARRY'S BAKERY
"Since 1923"
PHONE: 732-2434
2400 Fleet Street Baltimore, Md.
Open Sundays Closed Mondays

Angelina Casale (née Cala), from Villa Rosa, Sicily, immigrated in 1918 and opened Casale's Grocery in East Baltimore. She is pictured here in the 1930s. "My mom told me many stories about *Nonna* Angelina's store," said Mary Jean DeLauney. "*Nonna* knew which families were needy. As they purchased wares, she added an extra loaf of bread or pound of butter." Angelina baked Italian bread to sell. Her young grandson Paulie used to dig out the centers, push the loaves together inside the display case, and bite the butter. "My grandparents thought they had rats until one day they found him in action!" (Courtesy Mary Jean DeLauney.)

In 1953, Baltimore mayor Tommy D'Alesandro Jr. (who served from 1947 to 1959) and his wife, Nancy, traveled to Rome, Italy, for a private audience with the Holy Father, Pope Pius XII. They received special blessings for the people of Baltimore and for the couple's 25th wedding anniversary. Tommy and Nancy had known each other since childhood as students at St. Leo's School. They raised their children in Little Italy; one of them is politician Nancy Pelosi, another is Tommy III, who also served as mayor of Baltimore. (Courtesy Archives of the Archdiocese of Baltimore, *The Catholic Review*.)

The *Tommy* was Baltimore City's first diesel-powered fireboat and, at that point, the most powerful one the city had owned—capable of spraying 12,000 gallons of water per minute. *Tommy* was named after then-mayor Thomas D'Alesandro Jr., a resident of Little Italy. After it served the city from 1956 until 2007, the fireboat was decommissioned and sold for scrap, however, a significant portion was saved. The Fire Museum of Maryland in Lutherville is working to transport the boat to the museum in an attempt to resurrect it and put it on permanent display. (Courtesy Fire Museum of Maryland.)

Pictured in 1958, Concetta Serio was a produce vendor in Hollins Street Market, which dated from 1836 and was once Baltimore's largest market of its kind. Three days per week, colorful stalls extended along three blocks of Hollins Street, with some stalls run by second- and third-generation Italian families. (Photograph by A. Aubrey Bodine; copyright © Jennifer B. Bodine.)

In the 1953 picture below, six-year-old Lou Di Pasquale III stands in front of a Di Pasquale's delivery van. The family business was established as a corner grocery store in 1914 by his grandfather Luigi Di Pasquale Sr., who was from Abruzzo, Italy. Located in the ethnically rich community of Highlandtown, where many Baltimore Italians settled or relocated after initially living in Little Italy, the store still offers traditional recipes from the old country, fresh-baked bread and other products made daily, and the finest imported Italian foods. Di Pasquale's also has two other Baltimore locations, boasting four generations of continuous family operation. (Courtesy Di Pasquale family.)

In the 1930s photograph at left, Rosa Dello Buono Romaniello (with Scottie the dog) stands in front of Romaniello's Grocery at 1501 Bank Street, which she established in the early 1900s. Below, she and two of her children, Lena and Salvatore, pose inside the store. (Salvatore also worked at the Tack Factory on Central Avenue, as did many Italians.) Romaniello's closed in the late 1960s. Before its building was demolished for city housing projects, the store was located across the street, and it was haunted. "My mother Rose was setting a vase of flowers on the mantel," said Rose Prince Jackson, Rosa's granddaughter, "and saw a man in an old-fashioned suit—a ghost—floating above the floor. She dropped the vase and ran from the room to tell her sisters. They admitted they had seen him, too." Romaniello's sold fresh meats, cheese, snacks, and candy by the piece. When people did not have enough money to pay for groceries, a tab was kept. "Many never paid, but my grandparents would never refuse to give the neighbors food." (Both, courtesy Rose Prince Jackson.)

Pictured around 1923 at age 15, Joseph Montcalmo worked for Western Union as a bicycle courier delivering domestic and international telegrams to businesses and residents. He pedaled through all types of weather—"dependability" was the company's motto. (Courtesy Anthony Montcalmo.)

Four Corasaniti brothers from Calabria, Italy, arrived in the United States separately: Francesco "Frank" around 1900; Giuseppe "Joseph" in 1904; Vittorio "Vic" prior to 1916; and Giancinto "Gene" in 1924. Frank and Joseph worked for Leo Lavezza (Joseph's father-in-law), a road contractor based on Bank Street in Little Italy. In 1912, the brothers formed Arundel Construction, which was housed in a Trinity Street garage (later the site of DeNitti's Restaurant) until around 1938. When the Corasanitis moved their business to 4420 East Eager Street around 1940, they bought a hot mix asphalt plant from a firm in Syracuse, New York, disassembled it, moved it by rail, and reassembled it in Baltimore. Pictured in 1957 is Joseph Corasaniti (left) and his son Salvatore with a new excavator. (Courtesy Joe Corasaniti.)

The Monaldi Brothers is a popular musical group and a fixture during festivals, weddings, dances, and other Italian-related events. The five brothers and two sisters (Maria and Rosanna) grew up in Little Italy with their parents, Maria (née Vidi), a native of Pinzolo, Italy, and Olindo, a native of Pesaro, Italy, who emigrated in 1948 with $3 and a trumpet, which he played despite later missing three fingers. Olindo's legacy lives on through the talents of his sons, grandchildren, and great-grandchildren. Pictured at left on Easter in 1963 are the five brothers: Pete (accordion), Frank (drum), Frank's late twin Joe (trumpet), Olindo (holding a maraca and shielding his eyes), and toddler Mario. Pictured below in 1982 are, from left to right, Frank, Mario, Olindo Sr., Pete, Olindo Jr., and Joe. Today, the brothers play in a mix of musical groups: Olindo & Variety, soloist Pete Monaldi, Mario Monaldi & Sons, Mixed Company (with Frank's sons Frank Jr. and Steve), and Sham Boogie (with Frank's grandson Frank III). (Both, courtesy Monaldi family.)

The two gentlemen on the left in this 1950s photograph are Cesare "Charles" Cirelli (far left) and his son Anthony "Pete" Cirelli (second from left), who are playing Charles's hurdy-gurdy at a Belvedere Hotel event in Baltimore. The 648-pound, hand-cranked hurdy-gurdy was a piano-like instrument with a sound similar to bagpipes. It was challenging to pull it along cobblestone streets on foot around the city. Paper rolls of music inside generated melodies when the handle was turned. When songs ended, people offered a saloon drink, coins, fruit, bread, or canned goods to the operator. Cesare Cirelli and his brother Antonio from Genoa, Italy, once owned 16 hurdy-gurdies, which they played during 12-hour shifts and rented to others for $1 per day. In 2014, the Cirelli and Schiavo families donated their last hurdy-gurdy to the American Visionary Arts Museum in Baltimore. (Courtesy Delores Cirelli Walke.)

Gioacchino Vaccaro, born and raised in Palermo, Italy, established Vaccaro's Italian Pastry Shop in 1956 on Albemarle Street in Little Italy (across from today's location), bringing with him recipes and knowledge from Italy to make the finest Siciliano pastries Baltimore had ever seen. Today, "Mr. Jimmy's" son and daughter-in-law Nick and Maria Vaccaro continue the family tradition (cannoli is their specialty) with several Vaccaro's locations throughout the Baltimore area, including the most popular café in Little Italy. Nick is beneath the awning pictured above and with Maria in the below photograph. (Both, courtesy Maria and Nick Vaccaro.)

In the 1950s, Beatrice Yori owned Yori's store at 1519 Bank Street, near Broadway, until her death in 1964. Her daughter Natalie worked for her, and a son, John, delivered oil in Beatrice's oil truck. Their siblings were Joe, Victor, Guerrino "Goody," and Philomena. "My grandmom was a hard worker," said Sandy Aumiller, daughter of Victor Iori (later spelled Yori). "I remember her always in the store working. We visited her home in the back. My grandfather greased streetcar tracks for a living; when he became ill, my father left school at age 10 to take over that job." (Victor later worked at Bethlehem Steel welding warships.) Yori's stocked meats, canned goods, packaged bakery items, two-cent loose cigarettes, and candy. "Grandmom allowed me to wait on customers and use the huge antiquated cash register. On Sundays after eating spaghetti and meatballs, my cousins and I were allowed to have penny candy and Yoo-Hoo from the huge Coca-Cola cooler. We ran around between the store and kitchen. I remember her pinching our cheeks, saying, 'Ah, bella.'" (Courtesy Sandy Iori Aumiller.)

Bricklayer John N. Castagna (at left) is shown working on the Baltimore Federal Building in the 1960s. He worked for Castle Construction, which was owned by his brother Pete. A third brother, Joseph, was a bricklayer. Masonry was a common trade for Italians—some brought it from Italy, others learned it in the United States as they were forced to accept backbreaking labor when no better work was offered. For a time, Italians were among the poorest and most discriminated against immigrants from Europe. (Courtesy Peggy Liberatore Castagna.)

Vincenzo and Giovanni Greco founded Greco Brothers in Baltimore in 1972; the brothers arrived from Cefalù, Sicily, in 1965. Today, Greco Brothers Construction is in Arbutus, partly managed by Giovanni with Vincenzo's son Cosimo. From left to right are Luiz Guzman, Moises Balbino, and Dominick, Giuseppe, Giovanni, Cosimo, and Anthony Greco. (Courtesy Caterina Greco.)

Dora Aquia (pictured around 1969) is icing fish in her husband Samuel's seafood market on East Lombard Street in Jonestown, commonly dubbed "Jew Town" and "Corned Beef Row." Because Jewish and Italian vendors catered to shoppers who worked six days of the week, Sunday was often the busiest market day. Fish was a large part of an Italian's diet and could be purchased in fresh fish stalls around Baltimore city's markets, such as Market Place. (Photograph by A. Aubrey Bodine; copyright © Jennifer B. Bodine.)

The baking of fresh bread is in progress in this 1966 picture of F&S Maranto Italian Bakery on Pearl Street. The wholesale bakery was established in 1914 in Baltimore City by Francesco and Salvatore Maranto, immigrants from Cefalù, Sicily, who delivered their distinctive Vienna bread door-to-door around Baltimore neighborhoods. The bakery operated out of a Seton Hill neighborhood row house near Lexington Market. An expansion in the 1980s was necessary to accommodate the growth of the bakery, which then occupied four rowhouses at 244–252 Pearl Street. They were eventually demolished, and the site was rebuilt into today's bakery, which is owned and operated by Bill Maranto (third generation) and his children. (Photograph by A. Aubrey Bodine; copyright © Jennifer B. Bodine.)

Four
EVENTS, ACTIVITIES, SCHOOLS, AND SPORTS

A barrel of *vino* flows as a 1950s Italian festival is underway. Pictured are Vince Pompa (left) and Patsy Verdecchia (right). Red, white, and green candles—the colors of the Italian flag—sit on top of the keg. (Photograph by A. Aubrey Bodine; copyright © Jennifer B. Bodine.)

THE EVENING SUN—PLAYGROUND ATHLETIC LEAGUE
BASEBALL LEAGUES

ST. LEO'S PAROCHIAL SCHOOL

1931

In 1931, St. Leo's School entered a team in an *Evening Sun* baseball league. Later in the 1950s, a Little Italy league was formed, consisting of four teams: White Sox, sponsored by Corky's Tavern; Cubs, sponsored by Kelly & Poggi Pharmacy; Cardinals (pictured below in 1957), sponsored by Bagby Furniture; and Yankees, sponsored by Della Noce Funeral Home. "One kid, Nathaniel McFadden, was African American," said Andrew Lioi. "Racial segregation existed then, yet he was allowed to register. Later elected to the General Assembly, he wrote to the *Sun* paper thanking Little Italy for allowing him to play." The baseball field was next to the morgue and pump station along President Street (the pumping station still stands). "There's Toodie Geppi, top left [below]," said Bill Bertazon. "Fastball pitcher with no control, hit me numerous times! Scared the heck out of me." (Left, courtesy St. Leo's Church; below, courtesy Thomas C. Scilipoti.)

Many Baltimore Italians were natives of Abruzzo, Italy, like some of these bocce players from Bucchianico, which is located in that province. In Baltimore, they formed the Club of Bocce Bucchianico, which is pictured here on May 14, 1939. This picture was most likely taken near N. Curley Street, where most of the players lived within a few blocks of each other. "There was so much open space behind my house at 717 N. Curley Street," said Theresa Amadio Root, "until they built the Maryland Clothing Manufacturing factory. We called it 'the rolling hills.'" From left to right are Raphael Ricciuti; two unidentified men; Victor Zappacosta, Joseph Mammarella (kneeling at center), John Amadio, Nicholas DiMenna, Daniel Urbano Mammarella, Gus Zappacosta (kneeling, measuring ball), a different Joseph Mammarella (kneeling at right); and Anthony DiFillipo (standing at back right). (Courtesy Cathy Mammarella Melvin.)

This 1905 photograph shows the F. Votta & Bros. band. Although not everyone is identified, the image includes, in no particular order, (first row) Nick Pente (with tambourine) and Lawrence Votta; (second row) Tony Scatti, Benjamin DeRosa, Lou Votta, Frank Votta, a Mr. Milano, and Joseph Pente; (third row) Nick Roberto, Frank Peterra, Nick Barone, and a Gus. The band performed for events such as crab feasts and school dances. (Courtesy Joe Pente.)

The City Park Band pictured here in 1935 included Joseph and John Romaniello. In the vaudeville era, Joseph was also a musician at the Victoria Theater on Baltimore Street. Music was a vital part of Italian culture that immigrants brought to the United States. Marching and performance bands from the 1920s and 1930s likely had roots in the religious *feste* (festivals) in ancestral villages in Italy. (Courtesy Rose Prince Jackson.)

Above, the 1941 St. Leo's School all-male Drum Corps poses in the school courtyard. In 1942, the band joined the Junior Victory Army to help fight World War II on the home front. In the below photograph, the 1949 corps is marching on Patterson Park Avenue in Highlandtown. "In its 1952 to 1954 era, I was a drum major for its Drum & Fife Corps," said Joe Pente. "We performed at the first March of Champions at Memorial Stadium in 1954. My favorite memory is marching in a parade along Pratt Street to welcome the Baltimore Orioles to their new city and home on 33rd Street." Over the years, the band's name changed according to instrument configurations, and girls were invited to join. "Their style was high precision drumming and a slower paced marching, which offered a stirring sight and sound," said Pente. (Above, courtesy St. Leo's Church; below, courtesy Scalia family.)

Vorwaert's Boxing Team, 1933 champs, participated in a NIRA parade in Baltimore. NIRA stood for the National Industrial Recovery Act, a 1933 program passed by Congress and supported by Pres. Franklin D. Roosevelt to help the nation recover from the Great Depression. (Courtesy Michael Transparenti Sr.)

Born in 1915 and raised in Little Italy, Nicholas Transparenti (left) fought as an amateur and professional boxer in the 1930s. His three brothers were also boxers: Joe "Reds," a champion; Lou, a bantamweight contender who fought a 1941 world championship match and is in the Maryland Boxing Hall of Fame; and Phil, who went undefeated in 15 amateur bouts. A handful of talented boxers hailed from Little Italy. Some other Baltimore Italian boxers included "Killer" Marino, "Harry Jeffra" Pasquale Guiffi, "Baltimore Dundee" Ranzino, "Little Jeff" Cossentino, Leo Matricciani, Vince Lazzaro, "Joe Dundee" Lazzaro, Pete Galiano, Johnny Borozzi, Vince DeSantis, and the Fighting Longo Brothers. (Courtesy Michael Transparenti Sr.)

On a wall in St. Leo's Church hall is this September 21, 1932, Papal blessing, which reads: "Most Holy Father, the Children of St. Leo's School, Baltimore, duly approved by the Ecclesiastical Authority, prostrate at the feet of Your Holiness, humbly beg the Apostolic Blessing." Fr. Bernard Carman, the current St. Leo's pastor, offered a rough translation of the Latin at the bottom: "His Lordship kindly responds to your request given from the Vatican." (Courtesy St. Leo's Church.)

The 1946 graduating class of St. Michael's Business School included many Italian women who enrolled in its two-year program to study secretarial skills such as typing, shorthand, and stenography. The school was part of St. Michael's Catholic Church in Fells Point at Wolf and Lombard Streets, an 1857 landmark German church staffed by Redemptorist order priests that closed in 2011. It was transformed into a brewery in 2019. (Courtesy Scalia family.)

Italian dance groups have long performed in the Italian community, particularly during St. Leo's two summer Italian festivals. Street processions are a continuous portion of the festivals as well as on Easter and Mother's Day. Patron saint and the Blessed Mother statues are carried or carted, followed by a marching band and parishioners. The procession photograph below was taken during the 1950 Feast of St. Gabriele festival. (Left, courtesy Denise Giacomelli; below, courtesy Scalia family.)

Above, the Italian American Civic Club (IACC) of Maryland is shown acknowledging aeronautical cadets on July 30, 1956. The IACC is a 501(c)(10) fraternal organization founded in 1943 and is still active at 1214 St. Paul Street. The club is open to men of Italian descent, and it promotes the civic interests of Italian Americans through educational, charitable, and cultural activities. In the 1956 photograph below, members of the IACC pose during a cookout hosted by Mary (the only woman in the picture) and Anthony S. Federico Sr. at their Homeland residence at 5418 Springlake Way. Anthony (first row, second from right), an attorney, was a founder of the club. (Above, courtesy Denise Giacomelli; below, courtesy Phil Federico.)

This Knights of Columbus photograph is identified with a note that reads: "K of C, April 3, 1966, Cignatta, 3rd Degree Class—Council #205 honoring P.G.K. Francis M. Feeley; Grand Knight—Louis D. Patti, Jr." (Courtesy Scalia family.)

This women's Democratic Legion gathered in July 1960 during the Kennedy election. The banner at right reads: "Kennedy for President" and "Edward A. Garmatz for Congress;" Garmatz is pictured in the center of the first row. Between 1947 and 1973, Baltimorean Garmatz represented the 3rd congressional district of Maryland following the resignation of Thomas D'Alesandro Jr., who became the mayor of Baltimore. Garmatz was later indicted—and acquitted—in a federal bribery conspiracy case. The Edward A. Garmatz US District Courthouse sits at 101 West Lombard Street. (Courtesy Denise Giacomelli.)

A St. Leo's girls' basketball team is shown in action against SS. P&J (SS. Philip and James School) in Baltimore City. "My mother Charlotte was an excellent basketball player and St. Leo's organist for many years," said Carol Ciarapica Toth. "Since 1913, my grandparents, Mary [née Presti] and Charles Terzi, lived on Stiles Street two doors from the church." (Courtesy St. Leo's Church.)

This team was part of the Italian Soccer Association (ISA) on Ortman Field at Patterson Park in Highlandtown. Not all players are identified; however, the names of some of the pictured players include Joey Specca, Bobby Piccaco, Bobby Slawinski, Rolando Giacomelli, Bobo Shirack, Paul DiMarco, and Jimmy Cross. (Courtesy Denise Giacomelli.)

This late-1940s theatrical show was performed on a portable stage in St. Leo's School hall. The school also hosted fashion shows with the stage pieces positioned as a runway. "I graduated from kindergarten on that stage in 1964," said Will Matricciani, a St. Leo's School student through eighth grade. "The nuns produced plays for us to entertain our parents and classmates, such as *Scrooge*." (Courtesy Johnny Manna.)

The note written on this photograph reads: "Rev. Louis Lulli, Rev. Raymond Fiume and graduates . . . Class 1952, St. Leo's School." By 1979, the school's enrollment had fallen to 90, partly because of the nearby public housing units. It closed in 1980 after it became a drain on archdiocesan funds. (Photograph by Schavio; courtesy St. Leo's Church.)

The Cocoanut Grove Pleasure Club, with its male membership base, was not exclusively Italian, as noted by some roster names. "My uncle was a member, and he was 100 percent Polish," said Carl Sallese, whose father, Carmen Sallese, of 424 South Eden Street, was a member. "My mom Helen [née Oleksik] told me the club rented a house where members played cards and hung out. Women were allowed in yet could not become members." In February 1942, the club held its second annual dance at Italian Gardens, located at 806 St. Paul Street, a restaurant owned by Leo Allori and his cousin, Maria Allori. "It was the place where mobster Al Capone sent his men to fetch meals while he was being treated for syphilis at Johns Hopkins Hospital," said Stef Allori. (Both, courtesy Carl Sallese.)

COCOANUT GROVE PLEASURE CLUB

... OFFICERS ...

GEORGE KUCHICK	President
CHARLES CIPOLLONI	Vice-President
JOSEPH BALDASSARE	Treasurer
JOHN MOLINO	Financial Secretary
VICTOR LANCELOTTA	Recording Secretary
JOHN POMPA	Sergeant At Arms
NICHOLAS BACCALA	Ass't Sergeant At Arms

... CHAIRMEN ...

JOHN MOLINO	Chairman
GEORGE KUCHICK	Ass't Chairman
FRANK PICARELLI	Program Supervisor
JOHN POMPA	Ass't Program Supervisor
CHARLES CIPOLLONI	Publicity Supervisor
NICHOLAS BACCALA	Ticket Supervisor
NICHOLAS PASSARELLA	Ass't Ticket Supervisor

... COMMITTEEMEN ...

MICHAEL AMBROSE	JOHN MANTI
JOSEPH BALDASSARE	PETE OFFIDANI
JAMES GENTILE	GUERRINO YORI
VICTOR LANCELOTTA	PHILIP Di CHESS
ANTHONY PETTI	DOMINIC FRASCA
NICHOLAS FORTE	

... HONORARY MEMBERS ...

PAUL AMBROSE	CARMEN SALLESE
PVT. LOUIS FRASCA	SGT. ROCCO CHERNO
YEOMAN FRANK BACCALA	

• PLEASE PATRONIZE OUR ADVERTISERS •

During "Season 1920," Valeno's Concert Band is shown on the stage at Riverview Park, which opened in 1890 off Broening Highway in Baltimore. The amusement park gave the band daily bookings to keep guests from patronizing other parks, including Gwynn Oak, Carlin's Liberty

Heights, and Frederick Road Park. Riverview Park was where legendary Baltimore musician Eubie Blake got his career start. (Courtesy Denise Giacomelli.)

A 1973 street procession of the Feast of St. Gabriele Italian Festival winds through Little Italy. Established in 1928 by the St. Gabriele Society of St. Leo's, it features "monks" that emulate the saint's clothing; they are, from left to right, Lenny Butta, Anthony Azzaro, Gabe Mingioni, John Petti, and Paul Lioi. Pietro "Pete" Serafini (in a tie) is at left; Sal Petti (white shirt) is partially visible. Some of these parishioners have performed monk duty for over five decades. The Sun of Italy warehouse (at right) is a brand owned by the Pastore family, who acquired it as Sole d'Italia from Joseph Vaccarino. (Courtesy Scalia family.)

Annie Pat Popoli (left) and Rosalinda Mannetta (right) hold a Little Italy Community Organization (LICO) banner during a c. 1974 procession through the neighborhood. LICO was formed around 1971 to stop the construction of Interstate 83 through the neighborhood and is still active today. Dedicated to improving the quality of life for those who live, work, pray, and play in Little Italy, it also strives to preserve the community's Italian heritage. Note Sergi's Ice House Restaurant in the background at Albemarle and Fawn Streets; it was named after Sicilian immigrants Anthony and Mary Sergi, who established Sergi's Ice House in 1911. Their daughter, Jean Sergi Kidwell (one of 21 children), had transformed her parents' commercial ice business into a family-operated restaurant featuring Sicilian-style cooking. (Courtesy Scalia family.)

In the mid-1960s, a surge of Italians began to move from Baltimore City into Gardenville, inside the city line. Among other areas, some Italians settled near Walther Boulevard and some around Old Harford Road. Since bocce was a hugely popular sport, the Italians approached legendary councilman Mimi DiPietro to ask the city to build courts at Parkside Drive and Sinclair Lane. On a typical Sunday, over 20 men gathered for food, wine, camaraderie, and bocce, which involved yelling, arguing, and reconciliation. Pictured are, from left to right, Domenico Cannella, Egidio Durastanti, Fabio Giachini, Roberto Ascenzi, Alberto Tittoni, Gerlando Ascenzi, Guido Zazzetta, Lamberto Zazzetta, and Alceo Durastanti. Bocce is alive and well in the city, with ongoing leagues in Little Italy; some Baltimore Italian Americans even have bocce courts in their backyards. (Courtesy Frank Giachini.)

The group class photograph above shows fifth and sixth grade students of St. Leo's School in Sister Louis Mary's class during the 1962–1963 school year. At left, in May 1974, students play on the St. Leo's School playground in Little Italy, watched over by Sister Ancilla, principal and first grade teacher. "She was the most caring nun, but if we crossed her, we would know it!" said Ray Alcaraz. On social media, the Italian community posts fond recollections of their parochial school and its nuns. Open between 1882 and 1980, St. Leo's was staffed for many years by School Sisters of Notre Dame. (Above, courtesy Scalia family; left, courtesy Archives of the Archdiocese of Baltimore, *The Catholic Review*.)

Alexander DeSanctis (seated second from right), an Italian immigrant, was the bandleader of the DeSanctis Band of Baltimore. In 1920, he became a union member of the Local 40 Baltimore American Federation of Musicians. Two other identified people shown here are Joseph Serpico (back row, fourth from left), who played trombone, sometimes at Aldine Theatre on Baltimore Street, and Joseph Romaniello (left of the drum at center, holding a baritone). He and his brother John Romaniello also played in the Baltimore Municipal Band. (Courtesy Denise Giacomelli.)

"The accordion was very popular in Italian households," said Vince Piscopo (right). "Tommy Panto gave me lessons between ages 8 and 14." Piscopo and Marco DeSimone (left) play music during Italian community events; Marco on "*il mandolino*, the instrument most often connected with Italian music," he said. "We're members of the Italian American Civic Club where we often play, as a way of keeping in touch with our Italian roots and musical cultural heritage." (Courtesy Tracey Attlee Photography.)

The annual Columbus Day Parade (pictured in 1968) has been the longest-running Columbus commemoration in the nation for 128 years. It once began in Druid Hill Park, went south on Harford Road through Lauraville, and ended at the Columbus statue in Herring Park. More recently, it weaved through the streets of Baltimore City and ended at Columbus Piazza in Little Italy. In 2019, the full-fledged parade—after the wreath-laying ceremony where local Italian organizations lay flowered wreaths at the statue's pedestal—was scaled down to a smaller parade from the piazza into the neighborhood to kick off the first Italian Heritage Festival. On Independence Day in 2020, a large group of protestors marched into Little Italy to topple the Columbus statue, which was dedicated in October 1984 by Pres. Ronald Reagan and Baltimore's then-mayor, William Donald Schaefer. Police officers watched the destruction of the statue after they were instructed to stand down. The protestors tossed the statue's broken pieces into the Inner Harbor, but in less than 48 hours, the pieces had been retrieved by divers and transported to a sculptor for restoration. (Above, courtesy Peggy Liberatore Castagna; left, courtesy Devin Valenti Cherubini.)

Five
AROUND THE ITALIAN NEIGHBORHOODS

This delightful belly laugh does not need an explanation; of course, one may wonder what was so funny as an unidentified neighbor laughed with her friend Rose Quintiliani (right). Neighbors in Little Italy were like family, and everyone took care of and watched out for each other. (Courtesy Carmen Strollo.)

Pictured is the 1962 exterior of Our Lady of Pompeii at South Conkling Street, once a parish that was home to many Italians. Today, it continues to serve immigrants with a primarily Hispanic parishioner base. (Courtesy Archives of the Archdiocese of Baltimore, *The Catholic Review*.)

An annual May procession in Highlandtown was tradition for Our Lady of Pompeii Church. Here, the statue of the Blessed Mother is being carried along Claremont and Pratt Streets. Parishioners and others walked along with the procession and placed money on the statue as donations for the church. (Courtesy Di Pasquale family.)

"Thumbs up" for Salvatore Romaniello (left) and his neighborhood *amici* on Caroline Street in the late 1930s. Romaniello presumably prompted the pose as a laugh since he had a partial thumb and missing finger, which was lost in an accident while working at the Tack Factory on Central Avenue and Bank Street in the late 1920s. Because of his maimed hand, he was ineligible for the draft during World War II. (Courtesy Rose Prince Jackson.)

Pictured here at age 91, Rosaria Maria Addino Lioi digs in her vegetable garden on Arabia Avenue; she grew tomatoes, peppers, cucumbers, and string beans and maintained peach, fig, and pear trees. The *contadina* (peasant) from Sant'Andrea, Italy, was a robust and tough woman in body, spirit, mind, and personality. Planting crops was in her Italian blood; at age 9, she had stopped school to work in the fields on her family's property. (Courtesy Lioi family.)

The long, skinny backyards in Little Italy seem to be magical, as one can step off the street into the foliage of floral and vegetable gardens—and the proverbial Italian fig tree. "This is my great-grandparents' backyard," said Kimberly DePalmer. "They said they could grow a tomato plant in the crack of the sidewalk. They lived in two places in Little Italy, on South High Street and on Fawn Street." DePalmer's grandfather Anthony DePalmer is pictured at left. (Courtesy Kimberly DePalmer.)

Rosa Gentile (left) is pictured here with her children Maria, Josephine, and Jake; on the right is a cousin, Josephine Zito. (Courtesy Kimberly DePalmer.)

Street vendors often walked ponies and goats around neighborhoods to offer rides to children—and photo opportunities to their parents. Other vendors included the ice man, the coal man, the milkman, and a knife sharpener. "I could hear his bell ringing as he approached," said Joseph Santopietro, pictured in 1952 at age four in Logan Village. "He carried on his back a sharpening wheel on legs and set it up in the alley." Joseph's father, Joseph Saverio Santopietro, emigrated in 1921 at age 11 from Pontecorvo, Italy. (Courtesy Joseph Santopietro.)

Three-year-old Johnny Manna is pictured on a goat cart in 1941 on South Eden Street in Little Italy. Johnny was born in 1938 to Pasquale (Patsy) and Mary (née Tana) Manna, immigrants from Vasto, Abruzzo, Italy. (Courtesy Johnny Manna.)

FIFTEENTH CENSUS — POPULATION

State: Maryland
Incorporated place: Baltimore City
Ward of city: 6 (part of)
Block No.: 61
Tract: 3
Unincorporated place: no farms located in this district

Line	Street	House #	Dwelling #	Family #	Name	Relation	Home Data	Value	Radio	Farm	Sex	Color	Age	Marital	Age @ marriage	School	Read/Write	Birthplace	Father	Mother
51		204	336	381	Jackson, Robert	Son					M	Neg	25	S		No		Maryland	Georgia	Maryland
52				382	Lewis, Edward	Head	R	25.00			M	Neg	30	M	25	No	Yes	Virginia	Virginia	Virginia
53					— Bella	Wife-H					F	Neg	32	M	17	No	Yes	Virginia	Virginia	Virginia
54					— Marie	Daughter					F	Neg	5	S		No	Yes	Maryland	Virginia	Virginia
55		202	337	383	Thompson, George W	Head	R	25.00			M	Neg	65	M	21	No	Yes	Maryland	Maryland	Maryland
56					— Alice	Wife-H					F	Neg	67	M	23	No	Yes	Maryland	Maryland	Maryland
57					— Helen M	Daughter					F	Neg	16	S		Yes	Yes	Maryland	Maryland	Maryland
58		2322	338	384	Bowers, Joseph C	Head	R	35.00	R		M	W	49	M	34	No	Yes	Maryland	Ohio	Northumberland
59					— Margaret J	Wife-H					F	W	33	M	16	No	Yes	Maryland	Maryland	Maryland
60					— Virginia J	Daughter					F	W	16	S		Yes	Yes	Maryland	Maryland	Maryland
61					— Harry J	Son					M	W	13	S		Yes	Yes	Maryland	Maryland	Maryland
62		2320	339	385	Strovel, Daniel	Head	O	3,500	R		M	W	61	M	50	No	Yes	Germany	Germany	Germany
63					— Rose	Wife-H					F	W	48	M	24	No	Yes	Czechoslovakia	Czechoslovakia	Czechoslovakia
64					Schuchmann, Bernhard	Step-Son					M	W	17	S		No	Yes	Maryland	Maryland	Czechoslovakia
65					Phillip, Mary	Roomer					F	W	70	S		No	Yes	Maryland	Maryland	Maryland
66		2318	340	386	Butes, John	Head	O	3,500			M	W	41	M	23	No	No	Italy	Italy	Italy
67					— Josephine	Wife-H					F	W	42	M	24	No	No	Italy	Italy	Italy
68					— Alphonse	Son					M	W	16	S		Yes	Yes	Maryland	Italy	Italy
69					— Marie	Daughter					F	W	15	S		Yes	Yes	Maryland	Italy	Italy
70					— Anna	Daughter					F	W	13	S		Yes	Yes	Maryland	Italy	Italy
71					— Margaret	Daughter					F	W	11	S		Yes	Yes	Maryland	Italy	Italy
72		2316	341	387	Molino, Louis	Head	O	35.00			M	W	39	M	24	No	Yes	Italy	Italy	Italy
73					— Annie	Wife-H					F	W	35	M	19	No	Yes	Italy	Italy	Italy
74					— John	Son					M	W	13	S		Yes	Yes	Maryland	Italy	Italy
75					— Matilda	Daughter					F	W	10	S		Yes		Maryland	Italy	Italy
76					— Jean	Daughter					F	W	8	S		Yes		Maryland	Italy	Italy
77					— Louis Jr	Son					M	W	5	S		No		Maryland	Italy	Italy
78		2314	342	388	Wieprecht, Charles	Head	O	3500	R		M	W	30	M	23	No	Yes	Maryland	Poland	Poland
79					— Elizabeth R	Wife-H					F	W	36	M	29	No	Yes	Maryland	Poland	Poland
80					— Charles J Jr	Son					M	W	7	S		Yes		Maryland	Maryland	Maryland
81					— Gerard	Son					M	W	5	S		No		Maryland	Maryland	Maryland
82					Josek, Mildred E	Niece					F	W	10	S		Yes	Yes	Maryland	Maryland	Maryland
83		2312	343	389	Kane, Raymond J	Head	O	3,500	R		M	W	37	M	19	No	Yes	Maryland	Maryland	Maryland
84					— Eva E	Wife-H					F	W	37	M	19	No	Yes	Maryland	Poland	Poland
85					— Geraldine	Daughter					F	W	16	S		Yes	Yes	Maryland	Maryland	Maryland
86					— Joseph A	Son					M	W	13	S		Yes	Yes	Maryland	Maryland	Maryland
87					— Mary A	Daughter					F	W	13	S		Yes	Yes	Maryland	Maryland	Maryland
88					— Mildred J	Daughter					F	W	12	S		Yes	Yes	Maryland	Maryland	Maryland
89		2310	344	390	Lewis, Gordon	Head	R	35.00	R		M	W	28	M	21	No	Yes	Maryland	Maryland	Maryland
90					— Alice	Wife-H					F	W	26	M	19	No	Yes	Maryland	Maryland	Maryland
91					— Mary	Daughter					F	W	5	S		No		Maryland	Maryland	Maryland
92					— George	Brother					M	W	25	S		No	Yes	Maryland	Maryland	Maryland
93					— Norman	Brother					M	W	20	S		No	Yes	Maryland	Maryland	Maryland
94		2308	345	391	Weinknecht, John P	Head	O	35.00	R		M	W	53	M	29	No	Yes	Maryland	Maryland	Germany
95					— Emma	Wife-H					F	W	48	M	24	No	Yes	Maryland	Maryland	New Jersey
96					— John P Jr	Son					M	W	22	S		No	Yes	Maryland	Maryland	Maryland
97					— Fred	Son					M	W	20	S		No	Yes	Maryland	Maryland	Maryland
98					— Louise C	Daughter					F	W	15	S		Yes	Yes	Maryland	Maryland	Maryland
99					— Edith	Dght-in-law					F	W	50	Wd		No	Yes	Switzerland	Switzerland	Germany
100		2306	346	392	Fowler, John J	Head	O	3,500	R		M	W	29	M	24	No	Yes	Maryland	Maryland	Maryland

Part of a 1930 census included North Bradford and East Fayette Streets in Baltimore City. Most of the homes were valued at $3,500. Interestingly, 11 households held a diverse mix of European immigrants (and offspring) from six countries: Ireland, Germany, Italy, Czechoslovakia, Poland, and Switzerland. The two Italian families listed are John, Josephine, Alphonse, Marie, Anna, and Margaret Butro and Luigi and Annina Molino (the author's grandparents), who lived in Little Italy before relocating to Fayette Street in Highlandtown. They lost five children and had five others: John, Matilda, Jean, Louis, and Joseph. Luigi emigrated in 1907, Annina in 1913. (Courtesy Johnny Manna.)

95

"Everybody had a fig tree," said Philomena Scalia. "It's very Italian." Italians grew flowers, plants, and vegetables in postage-stamp backyards and plucked figs to eat fresh or to use in cookies and pies. Philomena's shotgun rowhouse at 913 Stiles Street is 75 feet long—or 100 feet with the backyard included. The "railroad" layout of a typical Little Italy house is so called for its configuration of rooms one in front of another, like train cars. Joe Scalia built this brick grill and single-handedly renovated the house. (Courtesy Scalia family.)

"I remember our fig tree was the 'official' gathering place for family photos, playing with cousins and friends, and of course, eating figs!" So said Josephine Zito Schmidt, pictured at center around 1959 with her brother Jimmy Zito (left) and her grandmother Guiseppina Zito at 920 Fawn Street. (Courtesy Josephine Zito Schmidt.)

This Little Italy map from the 1974 book *The Neighborhood* omits Eden Street to the east; Central Avenue is often mistakenly named as the easternmost boundary. Many Italians lived on Eden, Bank, and Gough Streets on the other side of Central Avenue. "Little Italy was about family." said Carmen Strollo. "You were considered family no matter on what street you lived." Two bakeries were also located on the other side of Central Avenue—Giordano's Bakery and M. Marinelli & Son Bakery, established in 1910 by immigrant Anthony Michael Marinelli. (Courtesy Bodine & Associates, Inc.)

The 1793 Star-Spangled Banner Flag House (pictured in 1957) is a National Historic Landmark and one of the oldest houses in Baltimore. Located on Pratt Street, it sits at the northern boundary of Little Italy and has housed Italian residents and businesses, including a pharmacy, a steamship ticket office, Banco di Napoli, and a telegraph service. It was once owned and occupied by Mary Young Pickersgill, maker of the original American flag that flew at Fort McHenry during the Battle of Baltimore in 1814. Today, it is a flag museum. (Photograph by A. Aubrey Bodine; copyright © Jennifer B. Bodine.)

Singer Peggy Lee is shown exiting Pizza's Restaurant (now Germano's) in 1949 with Charles Heyman (behind Lee) and Louis Chiapparelli (at right); the man behind Chiapparelli is unidentified. Family restaurants have operated in the area since day one of Little Italy, hosting celebrities, sports figures, and presidents. The building at 410 South High Street, down the street, has housed eateries for over 100 years. These have been owned by separate immigrant families, and today, the address is home to Café Gia, owned by Giovanna Aquia Blattermann and her daughter Gia Fracassetti (née Blattermann). Giovanna immigrated from Cefalù, Sicily, in 1953 with her brother Salvatore "Sammy" Aquia and their parents, Rose and Pasquale Aquia. (Courtesy Richard Heyman.)

Angeline DiDario (née Marmo; left) from Salerno, Italy, poses in 1959 with her daughter-in-law Florence, who married Albert DiDario. Angeline and her husband, Ernest, who was also from Salerno, had six other children and settled in South Baltimore. "Sadly, I never knew *Nonna* Angeline," said Suzanne DiDario George. "She passed when I was a year old. My childhood memories are the best, full of many wonderful Italian traditions, food, and family, which I carry on today with my family." (Courtesy Suzanne DiDario George.)

Impromptu singing in the streets can happen easily with an accordion. Pictured are, from left to right, (first row) unidentified accordion player, Mary "Babe" Grue, Concetta Marcantoni, Frank Marcantoni (Concetta's son), and Alphonse Grue (who owned Grue Clothing with his wife, Babe); (second row) unidentified, Jerry and Genevieve Della Noce, Alice DeGennaro, Anna and Rolando Giacomelli, and unidentified. (Courtesy Denise Giacomelli.)

In this 1930s image, John Pente stands next to his $12 Ford Model T. Pente attended St. Leo's School and parish and graduated from Calvert Hall. The Great Depression made it difficult for graduates to find work. Pente worked at several neighborhood businesses after school: shining shoes at a barbershop, shucking oysters for Maruzziello's grocer, and attaching handles to shopping bags at a bag company to earn 20¢ an hour. Later, he worked at Western Electric. (Courtesy Joe Pente.)

A 1964 group from Our Lady of Pompeii, then a predominantly Italian parish in Highlandtown, boards a jet for a "European Holiday" coordinated by Roma Travel Agency, owned by Gaetano "Guy" Sardella, who is standing behind the sign to the left of Fr. Robert Petti, pastor. As the "Voice of Italy" on Baltimore radio stations for over 40 years, Sardella was a leader for Baltimore's Italian Americans as he assisted immigrants in becoming acclimated to American life. His Sunday morning radio show, *The Guy Sardella Original Italian Hour*, began in 1940. In 1944, he helped to entertain Italian prisoners of war at Camp Meade, Maryland, by arranging visits with the Italian community and organizing sports and Catholic Masses. He taught Italian, worked as a correspondent for several Italian newspapers, and was a member of about six Italian organizations. Sardella is pictured below in 1946 with Nettie Candelieri; they were the godparents of baby Evelyn Giacomelli. (Both, courtesy Denise Giacomelli.)

This 1940 Blessed Mother Mary Miraculous Medal Shrine was once to the left of the altar in St. Leo's Church. "At the Shrine," reads a 1944 parish bulletin, "two signs, each bearing nine names of the boys in the service from St. Leo's . . . priests and people pray for them a special Novena every Monday evening . . . nine-day vigil lights burn at this Shrine almost constantly through the devotion of relatives and friends of the servicemen." Today, the Sodality of Our Lady, a decades-old ministry of the parish, continues to honor Mary through devotion and worship. (Courtesy Archives of the Archdiocese of Baltimore, *The Catholic Review*.)

The convent (pictured in the 1960s) and St. Leo's School in Little Italy were dedicated on November 29, 1931. Today, this building is occupied by the Xaverian Brothers. (Courtesy Scalia family.)

From Virginia, the Eastern Shore, and South America, vessels laden with fruit arrived throughout the summer at the Pratt Street and Light Street wharves. Andrew Lioi, who was 94 years old when this book was published, remembers "a huge door with a ramp attached opening on the side of the ships. Stevedores cradled stalks of green bananas [pictured at left in 1945] and delivered orders to waiting horse-drawn wagons, trucks, and handcarts." Some of the fruit was sold in Charles Conigliaro's store on Market Place and by Little Italy merchants "like Mr. Franco on Granby Street who stored bananas in his cellar and walked around neighborhoods to sell a dozen for 15 cents." (Photograph by A. Aubrey Bodine; copyright © Jennifer B. Bodine.)

In this 1936 photograph, an enormous batch of tomatoes sits dockside in Canton near Lakewood Avenue. Many Polish and Italian immigrant women were employed by the American Can Company while men served in World War II. "A sweat shop," said Andrew Lioi. "The canning process required heat and steam and there wasn't air conditioning back then." (Photograph by A. Aubrey Bodine; copyright © Jennifer B. Bodine.)

Little Italy neighborhood friends and brothers-in-law (from left to right) Zopito Salone, John Castagna, Tony DeSanctis, and Gaetano Ferrari are outfitted for a hunting excursion in this 1950s photograph. (Courtesy Peggy Liberatore Castagna.)

On Elrino Street in Highlandtown in the late 1950s, immigrant Gaetano Mosca (center) celebrated his 60th birthday with his children; they are, from left to right, Raphael, Maria, Victoria, Salvatore, Mose, Jenny, and Angela. Born in Gragnano, Italy, Gaetano emigrated first and later sent for an Italian wife—a stranger named Rose. During Prohibition, when it was legal to brew beer at home for personal consumption, Gaetano sold hops and barley in his store on "The Avenue" (Eastern Avenue). (Courtesy John Mosca.)

A 1968 Confirmation group is shown exiting St. Rita's Church in Dundalk; a bishop watches from the altar. Pictured at the bottom are Lucy Bianchi and her sponsor, Leonora Cabral. The parish once had a large Italian parishioner base. Other churches around Baltimore included many Italians, including St. John the Evangelist, St. Anthony's, St. Michael's, St. Patrick's, Our Lady of Pompeii, and Our Lady of Fatima. (Courtesy Bianchi family.)

In this 1941 image, orphans at St. Leo's Orphanage Asylum play instruments during a spaghetti supper (today's Ravioli Dinner). Located at 112 North Front Street, next to St. Vincent's Church, the orphanage was established in 1913 by Fr. Joseph Reidl, the pastor of St. Leo's. It housed over 60 Italian children who either had parents who were too poor to feed them, no parents, or just one parent. Initially for 13¢ a day, they were fed, clothed, housed, and educated through eighth grade. The orphanage closed around 1960. (Courtesy Archives of the Archdiocese of Baltimore, *The Catholic Review*.)

Chickens, ducks, and turkeys were slaughtered "while-you-wait" in Lombard Street stalls in Jonestown. Markets, such as Yankelove's Poultry House (pictured in 1969), are long gone from the once bustling "Corned Beef Row" where Italians shopped and worked. A lone deli remains—Attman's Delicatessen (started in 1915). Lombard, one of the city's oldest streets, is named after Guardia Lombardi, a town in Italy. A portion of the street near Little Italy was originally a slice of the Italian settlement. (Photograph by A. Aubrey Bodine; copyright © Jennifer B. Bodine.)

Lamplighters made twice-daily rounds to light, extinguish, maintain, and clean gas lamps along city streets. After the Gas Light Company of Baltimore transformed its street-lighting system to electric, in 1957, Mayor Tommy D'Alesandro Jr. turned off the last vintage lamp at Fawn Street and Slemmers Alley in Little Italy. "My great-grandfather William Hoffman, born 1884, stood on his bike to light the lamps," said Christine Stuart. "He was the last lamplighter." Hoffman is pictured here. (Photograph by A. Aubrey Bodine; copyright © Jennifer B. Bodine.)

Six
ITALIAN AMERICANS SERVING THE USA

Italian immigrant Frederick Cucco of Little Italy is shown playing a clarinet while serving in the National Guard around the 1930s. (Courtesy Scalia family.)

In 1953, at a US Coast Guard training base in Cape May, New Jersey, during the Korean War, seaman recruits engaged in small-boat exercises as they raced against seamen from other barracks. Upon graduation, they became seamen, first class. Carmen Meo drew arrows to himself in this photograph ("me") and to "a friend," Arnold Firesheets. Meo is the son of Italian immigrants Phillip Meo from Riposto, Sicily, and Silvera Fiori from Frosinone. "I was later transferred to Chincoteague, Virginia, US Coast Guard Life Boat Station," said Carmen, who grew up at 227 South High Street in Little Italy. (Courtesy Carmen Meo.)

World War II veteran John Leo Folio Sr. served in the US Navy from 1941 to 1945 as an aviation ordinance specialist stationed in Fort Meyers and Miami, Florida. Born in 1906 and one of eight children of immigrants Domenico and Margherita Foglio (the original spelling of their last name) of Little Italy, he attended St. Leo's School. (Courtesy George M. Folio and Ruthie Folio Robinson.)

This group is standing at the entrance of Luge's Confectionery in 1942; Luge's was a popular neighborhood hangout owned by Luca Granese. From left to right are Dom Sergi, George Durago, Antonia Granese, Lou Catalfo Sr., Lou Pizza, and Anthony "Don Jollio" Palmisano. Today, the site is home to Sabatino's Italian Restaurant, one of the oldest family restaurants in Little Italy—in operation since 1955 and now owned and operated by Vince Culotta and Renato Rotondo and families. The restaurant is named after Sabatino Luperini, an Italian immigrant who established it with a *paesano*, Joseph Canzani. (Courtesy Will Matricciani.)

"I'm named after my Uncle William Pompa, one of the neighborhood guys who made the ultimate sacrifice for his country," said Will Matricciani. "He was killed in action." Serving the US Army, Battery B, 165th Field Artillery Battalion, Pompa is pictured in Alaska during World War II; the United States was fearful the Japanese would attack through the Aleutian Islands. (Courtesy Will Matricciani.)

Twenty-seven-year-old Philip Romaniello (1915–1981) is pictured in his sailor uniform in East Baltimore before his ship departed in 1942. Once aboard, he had a premonition and "jumped ship." The ship sank, and the entire crew died. In a move that frightened the family, one day military police (MPs) busted into the family's store and house to search for Romaniello, who hid on the roof. After the war, he turned himself in and received an honorable discharge. Unfortunately, he suffered from anxiety and seldom discussed the incident. Romaniello was employed by Baltimore City. (Courtesy Rose Prince Jackson.)

Lena Romaniello (born 1910) is pictured around 1942 on Caroline Street with an Army friend named Whitey. Romaniello worked at a sewing factory during the war. Since she was a fast and accurate seamstress, she was tasked with the piecework of sewing the top stitching on military coats. "Aunt Lena said how tired her arms would get sewing those coats, since they were so heavy to handle," said Rose Prince Jackson. "Even into her eighties, she could make a sewing machine seem to fly." (Courtesy Rose Prince Jackson.)

Naval officer Anthony Votta (left) is pictured with his brother John Votta in a US Army uniform. John worked for 30 years at John Matricciani & Sons, a utility contractor with an office at 229 South Exeter Street. (Courtesy Will Matricciani.)

Paul Thomas Castello is the son of Mary (née Petrella) and Paul Francis Castello from Cosenza, Calabria. They lived at 1018 Fawn Street in Little Italy. The marksman sharpshooter served four years in the US Army, Signal Corps Division, as a private, first class during World War II in Saipan. He married Anna Casale, the daughter of Italian immigrants from Villarosa, Sicily, who owned Casale's Grocery in East Baltimore. Paul's father entered the country as Leopold Castelucci but was reluctantly forced to simplify his name by an immigration officer while being processed at Ellis Island. Paul Francis owned a barbershop on Abbotston Street at Harford Road. "My grandfather [Paul Francis] took the streetcar to work every day," said Mary Jean DeLauney. "Neither he nor my grandmother Mary learned to drive. My fondest memory is when I spent the night with them and the three of us walked to Broadway for a milkshake, then over to Lombard Street for bagels and tub butter." (Courtesy Mary Jean DeLauney.)

Pictured at their Winthrop Avenue (Hamilton) home in 1946 is the Vidi family; they are, from left to right, (first row) Maria, Pietro, and Maria; and (second row) Pietro, Fiori, Pio, and Nilo, three of whom had been drafted into the Army. Pio served in the Philippines. During a visit to inspect troops, a general tripped as he exited a Jeep. Pio broke rank to catch him and was promoted to sergeant. Pietro (Maria's twin) served as a mail courier between Seattle, Washington, and Anchorage, Alaska. Nilo was drafted after World War II and returned home before the Korean War. Because of his flat feet, Fiori was not able to serve; he and Maria helped their father run a knife-sharpening business. She drove the truck. "I'm sure it was a very difficult and emotional time for my grandparents," said Maria Monaldi Oma, "leaving their home country to come to America during the Depression, knowing it was better for their family, then sending off three sons to fight for their new homeland. They were proud to be Americans! I'm very grateful for being a part of their legacy." (Courtesy Monaldi family.)

Three Italian brothers who served the country were John Panzarella, Navy, and Sgt. Phillip Panzarella and Pvt. Carl Panzarella, both Army. Carl is pictured here in 1945 with his parents, Carmelo and Vincenza Panzarella, of Carswell Street. Phillip and John were deployed overseas; Carl enlisted four days after graduating from City College High School. He was a 1959 graduate of Maryland Law School and became a federal judge in 1972. (Courtesy Larry Martin.)

Sam Aversa is pictured in 1942 with his mother, Catherine Corasiniti Aversa, on North Port Street; he was not yet 18. When his naval ship transport was delayed out of North East, Maryland, he did not want to return home to further upset his mother after they had already bid each other an emotional goodbye, so he went to the movies to waste time and watched a Frank Sinatra film. Sam was stationed in Delaware and headed to the Pacific aboard the USS *Boston*. (Courtesy Cathy Aversa Coleman.)

These US Army pals training at Fort Jackson, South Carolina, in 1960 are, from left to right, Petey Belletti, Ralph "Skeezy" Cavaliere, Johnny Manna, Tony "Beans" Udeme, and Marco Scardina. Almost two decades earlier, there is mention in an August 7, 1942, *Sun* story about Louis Cavaliere (Ralph's uncle) organizing a war-support rally in Little Italy to honor the community's 85 soldiers. Mothers of the fighting men carried a large flag that read, "In honor of our boys—for God and for country—forever." (Courtesy Johnny Manna.)

Cpl. Louis Saverio Molino Jr. (the author's *papà*) of East Fayette Street, the son of Abruzzese immigrants Luigi and Anna, served in the US Army from 1951 to 1953 as a communication engineer. He is pictured with, from left to right, his brother John "Jay" Molino of Little Italy's Eden Street, his niece Carol Ann Molino, and his nephews Gary Molino and Robert Schaeferbein. "We still have his Army jacket," said Suzanna Molino. "Daddy felt highly proud of his service." (Courtesy Gary Molino.)

In 1943 and 1944, during World War II, Camp Meade in Maryland held over 1,600 Italian prisoners of war (POWs). Because Italy had surrendered to the Allies, the Italian POWs were treated better than the German prisoners and given special privileges. On Sundays, members of Baltimore's Italian community were allowed to visit the POWs and invite them to their homes. (One soldier in this picture is wearing an "Italy" arm patch.) The community transported picnic lunches laden with Italian food and spoke Italian with the prisoners. On air, WCBM radio personality Guy Sardella prompted folks to visit the prisoners, resulting in lines of cars motoring into the camp on weekends. He formed a soccer team and musical band and arranged for Catholic Masses and a visit from the mayor. During the war, the US Army captured almost 500,000 Italian, German, and Japanese prisoners and housed them in over 500 camps across 48 states. (Courtesy Johnny Manna.)

ST. LEO THE GREAT R. C. CHURCH

. . . I received your prayer book and Crucifix and I want to thank you for sending them to me. I shall keep them with me always. I also received the Parish Bulletin and find it very interesting.
 Pvt. Michael P. Petti, U. S. Army
 Australia

. . . I have never written to you before, but I should have had when I received the lovely devotional manual and Crucifix. The picture you see on this postcard is one of the beautiful Churches in Rome, St. Peter's.
 Pvt. Joseph P. Ciattei, U. S. Army
 Somewhere in Italy

. . . Received your gift and was very glad to get it. It was nice of you to remember me, and I will always keep it with me. I am sure all the boys who received one feel the same way I do. Thank you very much.
 Pvt. Louis Ferrari, U. S. Army, Alaska

. . . I have received your gift of the prayer book and Crucifix. I can't tell you how glad I am to have them. I always carry them with me wherever I go. Thank you for your precious gift . . .
 Pvt. Carmine J. Candido, U. S. Army
 Somewhere in Italy

. . . Here I am safe and sound. I know that the prayers of the people from St. Leo's Parish have helped me and the rest of the boys. I received a letter from a member of the Sodality telling me that the goal of clearing the school debt was reached. That's just fine. Through the cooperation of the good people of St. Leo's we will be able to achieve all the tasks which will be laid before us. Tell the people that now when the war is coming to an end they should not let up in praying . . .
 Pfc. Salvatore G. Rampolla, U. S. Army
 Somewhere in India

. . . I am sorry I haven't written to you before. I have been kept busy these days and find very little time to write. How is St. Leo's Parish doing? I really miss St. Leo's. I received the Parish Bulletin and appreciated it very much. Pray for us servicemen, especially for the boys fighting for us over in France and the other parts of this wartorn world . . .
 Pvt. Michael D'Adamo, U. S. Army
 Camp Croft, S. C.

. . . I should have written before but have been very busy with plenty of hikes, drilling and exercise. How are things back there? I guess there is not much left of the Holy Name the way they were taking them out when I left. I surely miss the old gang; give them my regards and I hope they are doing as good a job as when I left. As for me, I only missed Communion once on Holy Name Communion Sunday and that was because I had to work . . .
 Pvt. Anthony M. Tirocchi, U. S. Army
 Fitzsimmons Gen. Hosp., Denver, Colo.

. . . I thank you for the fine gifts you sent me and you can be sure they are deeply appreciated. I carry them with me every place I go and I believe they have brought me luck. The Devotional Manual fits easily into my pocket and is very handy. Father, have all the people pray for us, because it is only through the intercession of the Saints and the power of God that will bring us victory. If it is possible I would like to have a copy of the Parish Bulletin every time it comes out. I find it is very interesting reading . . .
 Pvt. Anthony T. Ottone, U. S. Army

Note—We will appreciate if Servicemen and their relatives will send in news for the Parish Bulletin. They are read with great interest, especially by the Servicemen serving overseas. It will keep them in touch with their friends.

A 1944 St. Leo's parish bulletin included notes from neighborhood boys serving in World War II. Another bulletin read: "Word was received by the family that Cpl. Ernest N. Ferraro, son of Mrs. Marie Ferraro, 130 S. Lloyd Street, died July 17 of wounds received as radio operator and aerial gunner in the New Guinea area. This is the first boy from St. Leo's parish to die in action." Other segments read: "John Pica, the popular young man of S. Exeter Street has seen combat in Italy. He was awarded the Silver Star, the Purple Heart, and Combat Infantrymen Badge for exemplary conduct in action against the enemy. . . . Pfc. Angeline C. Sudano of 302 S. High Street has received the good conduct medal at Turner Field, Albany, Ga.; Pfc. Benjamin P. Sudano of the same address has obtained a well-earned furlough in India. . . . Pfc. Frank R. Del Grosso of 910 Fawn Street has been awarded the silver wings of aerial gunner at the Harlingen, Tx. Army Airfield. . . . Cpl. Louis A. Bacigalupa of 311 S. Central Avenue has received the Expert Infantryman's Badge." (Courtesy Carl Sallese.)

BALTIMORE NEWS-POST

WEDNESDAY EVENING, DECEMBER 15, 1943 25

"MISSING" OFFICER RETURNS — Reported missing in action in July, 1942, Chief Petty Officer Francis Napolillo, Jr. (above, center), turned up at his home, 316 South Exeter street, recently, very much alive and well. But not even to his father (left), Francis Napolillo, would he talk of his experiences—"Security reasons," he said. On his lap he holds his nephew, Francis Blatterman. Napolillo has been in the Navy eight years and holds the Silver Star.

This December 15, 1943, *Baltimore News Post* photograph tells the story of CPO Francis Napolillo Jr. (center), who was reported missing in action July 1942 and one day showed up at his 316 South Exeter Street home in Little Italy "very much alive and well." He would not speak of his experiences—even to his father, Francesco Napolillo (left)—for security reasons. He is holding his nephew Francis Blattermann on his lap. Francis Napolillo was in the US Navy for eight years and received a Silver Star. "This is my grandfather, Uncle Francis, and me," said Francis Blattermann, a lifetime Little Italy resident. "My uncle was on the PT boats in the Philippines during World War II and was lost for about a year when his group was disbanded. He was left to survive in the jungle, contracted malaria, and finally rescued." (Courtesy Francis Blattermann.)

"I am reasonably certain this man is my grandmother's grandfather on her father's side," said Joe Corasaniti of his great-great-grandfather Lavezza. "His first name was possibly Leo. He was born in and emigrated from Genoa, Italy. My grandparents said he was a 'red shirt' in the *Risorgimento* [a movement for Italian political unity] and so enamored of the cause of liberty and union, he emigrated to the states after the Italian Revolution in 1863 and enlisted in the Union Army." Lavezza's hat has the Grand Army of the Republic insignia on it, evidence of his membership in the fraternal organization founded in 1866 after the Civil War and comprised of veterans of the Union army, Navy, Marines, and Revenue Cutter Service—all of whom served in the Civil War. The gold braid may indicate his officer's rank. (Courtesy Joe Corasaniti.)

This 1945 veterans' parade marching along South High Street in Little Italy was organized to dedicate the World War II memorial plaque hung on the exterior corner wall of St. Leo's Church. An older plaque dedicated in 1920 includes an Honor Roll of 79 names "in honor of these men of the parish who proved their loyalty to God and country during the Great World War." It also salutes the courageous men and women of the neighborhood who answered the call to defend the United States while serving in the Korean, Vietnam, and Gulf Wars. (Courtesy St. Leo's Church.)

In this 1942 photograph, Rose Romaniello fans 21 $100 war bonds—the most purchased during a Third War Bond Campaign conducted by Rustless Iron & Steel; she worked in its metallurgical department polishing metals and mixing formulas. Romaniello's family helped her with the large purchase. Americans purchased these bonds as a way to help the government finance World War II and purchase troop supplies. Bonds appealed to civilians' emotions and helped them feel useful and involved. The Series E Bond was the last official war bond sold in the United States by the War Finance Committee. (Courtesy Rose Prince Jackson.)

Pictured while serving in the US Army during World War II, Charlie Giro stands with Albert Riggio and two other Army buddies behind a promotional sign for a Lena Horne show in San Antonio, Texas. As the war approached, it was estimated that nearly one million Italian Americans served in the armed forces, and millions more were employed in war-related industries. After the war, many returning servicemen got married and moved out of Little Italy. (Courtesy Denise Giacomelli.)

Carmelo Giro, 25, is pictured in 1945 in his US Army uniform. He was the oldest of five children of Rosa (née Meo), from Sicily, and Nicola Giro, from Abruzzo. "He was wounded in the Invasion of Normandy and Battle of Saint-Lô, France, which left shrapnel in his head," said Denise Giacomelli, Carmelo's goddaughter and niece. "Thankfully, it didn't affect him. He was a sweetheart and I miss him; he died at 61." Carmelo received a Purple Heart. After marrying, he lived in Little Italy, then Essex. (Courtesy Denise Giacomelli.)

Visiting servicemen on liberty, pictured here with Mary DeSanctis during World War II, were invited into the DeSanctis home in Little Italy to be fed a hot meal. Often, they wandered into the neighborhood from their ships docked near the Inner Harbor; some restaurants offered the boys free meals. After they got married, Mary and her sister Rita stayed in the home of their parents (Mary [née Trombetta] and Alexander DeSanctis) with their husbands Zopito Salone and John N. Castagna, respectively. The girls' brother was Tony DeSanctis. It was common for an Italian residence to house several generations, which allowed for affordability, support, necessity, and family closeness. (Courtesy Peggy Liberatore Castagna.)

Despite his age of 36, Joseph Montcalmo was drafted into the US Army in 1944. He and his wife had four children between the ages of two and nine, and the couple cared for Joseph's elderly father, John, who lived with them. As an ammunition carrier, his machine gun unit was preparing for combat in this 1944 photograph, possibly taken in Belgium during a critical time near the end of World War II when troops were needed in war zones to counter the German offensive. Montcalmo was wounded in the Battle of the Bulge when his unit entangled in an artillery barrage and a shell exploded behind him. As he leaned onto a jeep while attempting to stand up, the driver called, "Get off the jeep, you're getting blood all over it!" Joseph's shrapnel injury in his shoulder led to his subsequent discharge; he was awarded the Purple Heart. Unable to return to his full-time profession as a printer, he worked that job part-time as well as two others—at the US Postal Service and at a bakery. (Courtesy Anthony Montcalmo.)

HEADQUARTERS 84TH INFANT[RY]
OFFICE OF THE COMMANDING GE[NERAL]

RAILSPLITTER

Award of the Bronze S[tar]
(BRONZE OAK LEAF CLUSTER)
Citation

Private First Class ALBERT E DI DARIO 33896722, 333d [Infantry,]
Army. For heroic service in connection with military [operations against the]
enemy in Germany, 10 April 1945. When a large motoriz[ed column was tempo-]
rarily halted by a bridge on which nine demolition bom[bs were placed and]
no engineers were available to remove the explosives, [Private First Class]
Dario voluntarily moved across unfamiliar terrain with[out the benefit of]
any covering fire and successfully removed the bombs a[nd defused them.]
The cool courage, loyalty and initiative displayed by [Private First Class]
Dario enabled the column to resume its advance and are [in keeping with the]
finest traditions of the military service. Entered mi[litary service from]
Maryland.

A. [R.]
Major Gene[ral]
Co[mmanding]

Pfc. Albert DiDario, son of Ernest and Angeline DiDario of 412 Grace Street, was awarded an Oak Leaf Cluster to his Bronze Star Medal "for heroic service in connection with military operations against the enemy in Germany, April 10, 1945. When a large motorized task force was temporarily halted by a bridge on which nine demolition bombs had been placed and no engineers were available to remove the explosives, Private First Class DiDario voluntarily moved across unfamiliar terrain without the protection of any covering fire and successfully removed the bombs after detaching the fuses. The cool courage, loyalty, and initiative displayed by DiDario enabled the column to resume its advance." His initial Bronze Star Medal was presented "for heroic service against the enemy in Germany and Belgium Nov. 19, 1944–Jan. 20, 1945 when he voluntarily removed an unexploded shell from the vicinity of his battalion on command post, and led a group in clearing a cellar of a suspended booby trap." (Courtesy Suzanne DiDario George.)

Pictured around 1941, Carmen "Buster" Louis Bertazon (1923–1987) served in the US Army for two years, stationed in Fort Gordon, Georgia, as he trained with the Army Signal Corps to monitor intelligence information during World War II. He lived at 900 East Pratt Street in Little Italy with his parents, Kate (née Liberto) and Ignazio "William" Bertazon Sr., an immigrant from Sernaglia Della Battaglia in Treviso, Italy. Ignazio arrived at Ellis Island at age 17 with two brothers, Benjamino and Guido, aboard the SS *Duca d'Aosta*. (Courtesy William Bertazon.)

Another son of immigrant Ignazio "William" Bertazon Sr. is William "Billy" Bertazon (pictured in 1964), who did his basic training at Camp Perry Great Lakes, Illinois. He was stationed aboard the USS DE 749—a cannon class destroyer escort naval reserve training ship. Billy participated in monthly training exercises at Fort McHenry in downtown Baltimore for marine navigation, international communication, and firepower. "I was home every month," said Billy. "My mother Marge [née Marino] asked me, 'What kind of Navy are you in?'" (Courtesy William Bertazon.)

Little Italy resident Paul Ambrose wrote a friendly greeting on his US Navy portrait; he served from 1944 to 1945 and was stationed in Bainbridge, Maryland. Paul was born in 1918 in a second-floor apartment above Pastore's Italian grocer on East Lombard Street. His parents were Jennie Ambrose (née Nigro) of Brooklyn, New York, and immigrant Leo Di Ambrosio (his surname was later changed to Ambrose), who was born in Peschici, Italy in 1892. Paul was baptized at St. Leo's, married Mary Brocki in 1941 at St. Patrick's, and worked as a post office clerk until his retirement. He died in 2002. (Courtesy Barbara Ambrose Pawloski.)

Michael N. Transparenti Sr., US Army Signal Corps, served for two years, from 1968 through 1970, and was in active duty. He exited the Army as a sergeant. (Courtesy Michael Transparenti Sr.)

Discover Thousands of Local History Books
Featuring Millions of Vintage Images

Arcadia Publishing, the leading local history publisher in the United States, is committed to making history accessible and meaningful through publishing books that celebrate and preserve the heritage of America's people and places.

Find more books like this at
www.arcadiapublishing.com

Search for your hometown history, your old stomping grounds, and even your favorite sports team.

Consistent with our mission to preserve history on a local level, this book was printed in South Carolina on American-made paper and manufactured entirely in the United States. Products carrying the accredited Forest Stewardship Council (FSC) label are printed on 100 percent FSC-certified paper.

MADE IN THE USA